CONNECTICUT
RIVER FERRIES

CONNECTICUT RIVER FERRIES

Wick Griswold & Stephen Jones

THE
History
PRESS

Published by The History Press
Charleston, SC
www.historypress.com

Copyright © 2018 by Wick Griswold and Stephen Jones
All rights reserved

Cover image courtesy of the Rocky Hill Historical Society.

First published 2018

Manufactured in the United States

ISBN 9781467138079

Library of Congress Control Number: 2017963225

To my father, Edward P. Jones, who took me on my first ferryboat ride and spent many a time expanding on that moment for the rest of his life. And to the memory of his mentor, Captain Sam Miner, of the Connecticut River.
—*Jones*

To my redoubtable cousin Irving Humphrey Austin Jr., who slept in the engine room of the Cumberland as a lad.
—*Griswold*

CONTENTS

ACKNOWLEDGEMENTS

First and foremost, an eternal thank-you to Catalyst and Muse Jacqueline Talbot for facilitating the confluence of Jones and Griswold, a truly wondrous circumstance, and to the captains and crews of the Connecticut ferries who unstintingly shared their experiences, wisdom and sources. They are who truly made this book possible. Captains Tom Darcy, Jim Grant, Ben Hawkes, Cathey LaBonte, John Marshall, Blaise Clemente and Larry Stokes deserve a standing ovation, as do crewmen Sal Spatola and Joe D'Amico. Megan Barry, aka Bo Peep of the Black Sheep, provided victuals, smiles and much-needed technical support.

Wick Griswold would like to thank his support team of the University of Hartford; they were all their usual resourceful and helpful selves. The inestimable Bonny Taylor; the talented Mario Maselli; my evil twin, Woody Doane; Dean David Goldenberg; and the College of Architecture's James Fuller all provided valued functions. Amy Trout at the Connecticut River Museum and Sierra Dixon at the Connecticut Historical Society were excellent sources of important historical images and information. Dani McGrath of The History Press sparked the initial impetus to put this project on the water. Chad Rhoad was very helpful. Frederick Schavoir's friendship, artwork, puzzling skills and knowledge were terrific as usual. Jennah Smith did splendid camera work and was resourceful and fun. And as always, Annie and Maggie Mae, the Bulldozer, were there to inspire, support and provide laughter and enchiladas.

ACKNOWLEDGEMENTS

Stephen Jones also would like to thank Caleb Lincoln of the Connecticut River Museum, John Lewis of Essex Boat Works, researchers Andrew Blacker and Tom Steenburg, Lou Torregrossa for technical support and Bailey Prior for research and technical help. Special thanks to Captain Geoffrey Jones of the oyster boat *Anne* for encouraging me to bounce boat-handling ideas off him and my wife, Hansina Wright, for support on my ferryboat forays, both mental and geographical.

INTRODUCTION

For thousands of years, humans crossed rivers on ferries. Before bridge-building technologies evolved, ferries were the only way travelers could get from side A to side B and stay dry. They have long been symbols and metaphors for transformation and transition. The archetypal ferryman, one Charon, is one of the best-known figures in Greek mythology. He is the cranky boatman who transports souls of the departed across the river Styx into the land of the dead. Ferries play key roles in economics, geopolitics and the daily life of riparian residents and wayfarers. Ferries first appeared on the Connecticut River almost four centuries ago. They were powered by oars, sails, poles, cables and horses. Today's boats are propelled by diesel engines, but they still perform the basic function of taking people and cargo from one side of the river to the other. The history, lore and legend of ferryboats on the "Long Tidal River" compose unique elements of Connecticut's heritage and culture.

The first ferries on the Connecticut were birch bark or dugout canoes or logs lashed together to form rafts that could be poled or rowed and were able to carry animals and cargo. When the Puritan minister Thomas Hooker arrived in Connecticut with his pioneering party from Massachusetts, their cattle and gear were carried to the western shore on driftwood rafts. As the English colonists settled in, ferry-building technology improved due to metal tools and woodworking skills. Soon after the first English colonists arrived, ferry service was established at several spots along the river, usually at places the river Indians used as crossing points.

By the middle of the seventeenth century, informal ferries—usually sail- or oar-powered flat platforms—were in operation between Saybrook and Lyme. In 1642, the Connecticut General Court initiated formal service between these two communities. Upriver, a ferry was established in Windsor by Captain John Bissell in 1638. The Bissell Bridge that connects Windsor to South Windsor today bears his name. Service between Rocky Hill and Glastonbury began in 1655. Hartford granted Thomas Caldwell the rights to a ferry in 1681. Ferries formed an important part of the economic and social infrastructure of the early colonies. Before bridges were built, ferry service was a must for those who wished to transport agricultural or manufactured products.

Given the difficulties of travel in colonial times, wayfarers often planned their journeys so that day's end would find them at a ferry landing. The ferry operator was often an innkeeper as well. Ferries were sources of information and news as travelers paused to refresh, dine or rest for the night. They were also vital links in mail and courier routes. The ferryman was often the most up-to-the-minute informed member of his local community. In pre-telegraph times, the ferry was like a slow URL on the Internet.

The eighteenth century saw ferry service proliferate up and down the river. As the population of New England grew and travel and commerce expanded, ferries were launched to meet the needs of travelers. Often, ferry crossings were quite close to one another and directly competed for customers. Although ferry rates were set by the state, it was not unusual for operators to undercharge to beat the competition. But it was much more likely that the ferryman would overcharge the hapless traveler who had no other means of getting across the river. Court records document several instances of price gouging by unscrupulous boatmen.

Early ferries across the Connecticut were propelled by oars, poles and sails. Some ingeniously used the river's currents to move their boats. A cable would stretch across the river, and when the ferry needed to cross, the cable would be pulled up and attached to a pulley on the boat that pulled it along as the flow of water pressed against the ferry's hull. When the ferry was idle at either shore, the cable would be dropped and other boats could pass by unobstructed. Some ferries were driven by one-horsepower mechanisms—literally one-horse power. A horse would stand on a treadmill, and as it plodded along, always remaining in the same place, the treadmill would turn a paddle wheel to push the boat to the far shore.

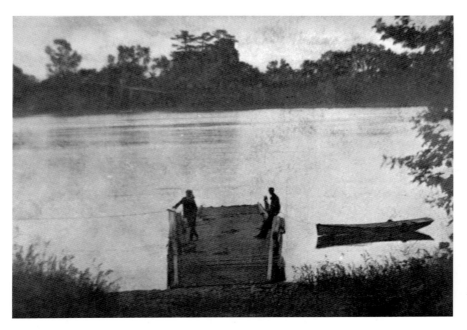

Bissell's cable ferry was established in Windsor in 1638 and operated into the twentieth century. *Courtesy Captain Larry Stokes. Photo by Jennah E. Smith.*

In the early nineteenth century, steam quickly changed the way ferries were propelled across the river. Boats such as the *Lady Fenwick* and the *Colonial* chugged across the water between Saybrook and Lyme. With the advent of railroading, the steamboat interests along the river fiercely opposed the building of bridges to accommodate the increasingly popular trains. Before a railroad bridge was finally built at the mouth of the river in 1870, train cars were uncoupled at the river's edge, loaded onto barges, ferried across the river and reconnected to an engine on the opposite shore to continue the journey to Boston or New York.

There have been more than one hundred ferries operating at various times along the river. But bridge construction and the coming of the automobile decreased the need for them. By the early twentieth century, only the Rocky Hill–Glastonbury and the Chester-Hadlyme services remained. They could no longer be run profitably by private concerns, and their management was taken over by the state. The Hadlyme boat was kept running as a tourist amenity to Gillette Castle. The Rocky Hill boat continued because of its historic status as the nation's oldest continuous ferry operation and its use by commuters. As fuel costs rose along with

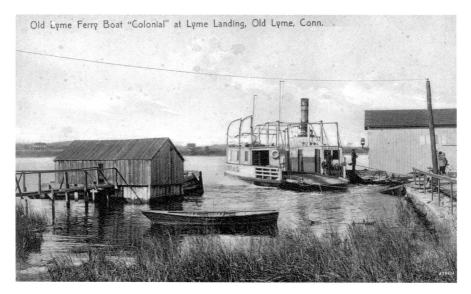

Old Lyme Ferry Boat "Colonial" at Lyme Landing, Old Lyme, Conn.

Ferry service between Old Lyme and Old Saybrook began in 1642 and lasted until a bridge was built across the river in 1911. *Courtesy of Connecticut River Museum.*

union-mandated salaries and benefit packages for crews and maintenance costs increased, the political and fiscal expediency of continuing the ferry service came under intense scrutiny.

As of this writing, the two remaining Connecticut River ferries still happily make their way across the river. State budget woes have resulted in across-the-board spending cuts and political turmoil. But the ferries have, remarkably, remained unscathed. The strong support they receive from grass-roots citizens groups has protected them, so far, from the budget axe. It is the hope of the authors that they will continue to run far into the future. Ideally, this book will inspire you to be an advocate for their continued survival. At the very least, we encourage you to take a ride on both of these historic vessels every now and then.

FAMILY AFFAIRS

For much of their pre-steam history, Connecticut River ferries were privately owned by individuals. Since a ferry is a place on land, as well as a boat, ferry services were often contingent upon who controlled the property rights at the best landing places. As a result, ferries passed down from generation to generation, usually along patrilineal paths. The biblical names of some of the early owners read like the series of begats in the Bible. Hezikiah, Jabez, Juduthan, Zephaniah, Caleb, Elizur, Ebenezer, Epaphras, Erastus, Eleazer, Elijiah and Levi were some of the given names of early ferrymen, reflecting the Puritan heritage of the early English settlers in the Connecticut River Valley. Since these settlers practiced primogeniture, the bequeathing of legacies to the eldest son, some of the ferry services were controlled by the same family for generations.

For example, a ferry was established in Saybrook in 1662 by John Whittlesey, and that ferry service was operated by the Whittlesey family for almost two hundred years. It was conveyed to the town in 1839—a remarkable stretch of intergenerational proprietorship. Interestingly, given the vagaries of wind, tide and current, Whittlesey's ferry often washed up on one side of the river or the other on land that did not belong to the family. Statutes were enacted that granted easements to passengers wherever the ferries wound up, so they might continue their travels.

As early as 1649, Joseph Smith began a ferry service between Rocky Hill and Nyaug, a section of South Glastonbury. He apparently operated on a freelance basis for a few years, and his service became officially recognized

in 1655, thus the claim of the oldest ferry service in the country. In 1724, the Connecticut General Court granted the stewardship of the Rocky Hill–Glastonbury Ferry to his son, Jonathan Smith. The court stipulated what Smith could charge for his services. Fourpence for a man, horse and load and twopence for a person on horseback were the going rates. The ferry at that spot had already been in existence for nearly a century by then.

Jonathan operated the ferry for several years, until health problems compelled him to give up the strenuous work. He passed the boat along to his twenty-three-year-old son, Nathan. The young lad enthusiastically took up the family poles, sails and oars. But his tenure as owner and captain was cut short by his untimely death at age twenty-eight. He left no male heirs, but Hezikiah Grimes, who was married to one of his sisters, petitioned the court to allow him to continue the service. As such, it still remained in the family, if a bit tangentially. The court ruled in his favor because he and his wife lived where Jonathan and Nathan dwelled and the "boats and necessities required for the service were already at hand."

All was not love and harmony in that family, however. Daniel Clark, the husband of Nathaniel's other sister, went to the court and claimed that Hezikiah was neglecting the ferry and didn't think it would be possible for him to continue the service. To further complicate matters, he and his family moved into the ferry house. Jonathan Smith's widow, Hannah, who had some legal sway in the matter, avowed that she wished Daniel to operate the ferry and told the court that was her wish. The court disagreed, and Hezikiah captained the ferry until his death in 1749.

The ferry then passed to his widow, Abigail Smith Grimes, who lived for another forty years. During her lifespan, the ferry was controlled by members of her family. After her demise, the ferry passed to the heirs of her son, John. The husband of John's sister, one Elizur Goodrich, successfully operated the boat for a few years. Upon his death and that of his wife, the service fell into the hands of their young children, who claimed it as their birthright. The underage survivors struggled to maintain the service but were unable to do so. Complaints started piling up of price gouging, dangerous boats, faulty service and poor seamanship. As a result, the service was rented out to other, more qualified operators until the Goodrich heirs reached adulthood.

The reign of the Smith family was not always an easy one. Although familial relationships aren't exactly clear, other Smiths, throughout the early centuries of ferrying in Rocky Hill, vied for the privilege to operate the boat. In 1673, a Richard Smith was appointed to keep a ferry "over the Great River at New London Road and give entertainment to strangers and

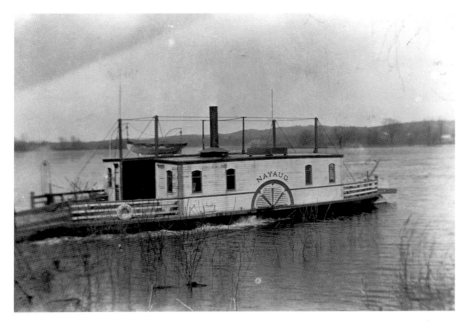

The steam ferry *Nyaug* was named for a section of South Glastonbury. *Courtesy of the Rocky Hill Historical Society.*

travelers in the same road as occasion may serve." This operation became known as Smith's Ferry. But interfamily rivalry soon caused him to go to the general court to fend off the prospect of competition by yet more Smiths.

Half brothers Benoni and Timothy Smith became a presence in the business when they took over a ferry slightly upstream of the other Smiths established by Richard Keeney. An interesting footnote in their personal histories was that their grandfather Lieutenant Phillip Smith was purported to have been murdered by "a hideous witchcraft." Apparently, the general court allowed all the Smith ferries to coexist.

After the death of Richard Smith Jr., the Glastonbury ferry passed to his son Benjamin. Later, it fell under the purview of another son, Manoah, after his brothers Richard and Jeduthan each took a turn of a couple years at the helm. For a brief period, the ferry fell out of Smith family hands and was operated in 1737 and 1738 by Thomas Sparks and Elisha Loveland. During this interregnum, Richard Smith petitioned the court to disenfranchise the Sparks/Loveland outfit. He claimed that he "built a house on the banks of the river for traveler's convenience and provided at all times a good tight boat well furnished with oars." He claimed that

the interlopers set up shop just downstream of his traditional spot to undercut his business. He argued that he would be summoned across the river to fetch a fare, only to find that Sparks and Loveland had beat him to the other side and scooped up the paying customer. This caused him to deadhead back across the river with nothing to show for his labor. His wish was to have the upstart ferrymen remove themselves farther down the river so as to reduce the competition at a place that had traditionally been the purview of the Smith family. He produced several witnesses who claimed that they had called Sparks or Loveland to cross the river to fetch them, but they had refused to render service. In spite of Smith's impassioned pleas, the court ruled against him, and his competitors were allowed to continue in business at the contested location.

The Smith family was just one of several who operated ferries as legacies on the river. The progeny of patriarch Captain John Chapman in East Haddam kept a ferry from 1684 to 1831, for a total of 147 years. In 1735, Jabez Chapman petitioned the General Assembly to grant a license to keep a public house at the site of his ferry. He maintained that he and his father had maintained the ferry for 40 years with great difficulty and very little profit. He had been arrested for dispensing food and drink but claimed that he only did so when "humanity demanded it." He hoped that an inn would allow his ferry to turn a profit for a change. His license was granted.

Despite on-and-off competition from a series of upstream ferries, the Chapmans continued to maintain and operate their ferry throughout the eighteenth century. It stayed in the family when, in 1807, Jabez Chapman conveyed the operation to his son-in-law Solomon Blakeslee. Blakeslee ran it until 1831, when he sold it to Joseph Goodspeed. The ferry then stayed within the purview of the Goodspeed family. It was successively owned by William H., George and finally William R. Goodspeed. The Goodspeeds operated ferries in conjunction with their steamboat line and opera house.

Although no longer owned by family members, the name Chapman's Ferry clung to that location into the twentieth century. Chapman's Ferry went out of service completely on June 14, 1913. The steam ferry *General Spencer* made her last trip, and there was a brief ceremony to mark the ending of a historic presence in Connecticut. Her demise was attributed to the completion of the East Haddam Bridge. The proliferation of bridges resulted in a dwindling number of ferries in the state. At the time, Bissell's still ran in Windsor, and there was also a service in Higganum that was soon to come to an end.

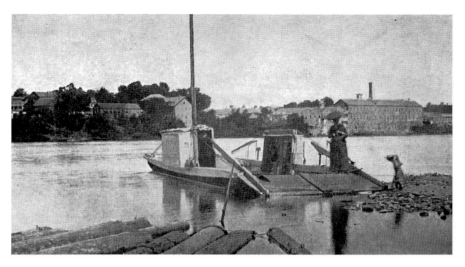

Ferry service at Windsor Locks Warehouse Point dates to the early eighteenth century. *Courtesy of the Connecticut River Museum.*

A family dynasty began between Windsor and Warehouse Point, but it was short-lived. In this instance, the General Assembly granted ferry privileges to James Chamberlain in 1783. A decade later, he transferred it to his son, also named James. Junior held on to it until 1801, when it was sold out of the family to Samuel Denslow. It was sold in 1806 to Samuel Heath for $50. In 1815, its two-scow operation went to Solomon Terry for $300. In 1816, it went for $360 but depreciated in 1819 down to $325. Men named Chapin and Douglas operated it until 1885, when the ferry franchise was sold to the Warehouse Point and Windsor Locks Bridge and Ferry Company for the tidy sum of $20,000.

One interesting variation on the family ferry theme involves the service that Samuel Colt initiated to bring his "family of workers" from company housing in East Hartford to the dock of his factory in Hartford. Although it was officially incorporated as the Union Ferry, no one ever called it anything but Colt's Ferry. One of the rationales for its existence was that his workers would not have to pay tolls to cross the river by bridge. It was also believed that the ferry would save time for the workers and give them a bit more leisure at home with their families. It also ensured that those who made it aboard would arrive to work in a timely fashion.

Colt's Ferry came into existence in June 1857 at a high-water mark of the Industrial Revolution. As an indication of the political power of the

The barge *Hollister III* at the Essex Boat Works Dock. She is ready to head up the river for another season carrying vehicles, cyclists and "footmen." *Photo by Jennah E. Smith.*

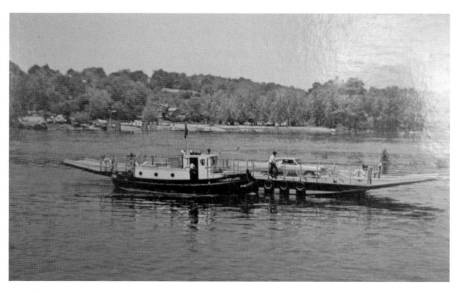

The *Cumberland* and the *Hollister III* heading east toward Glastonbury on a summer day in the 1950s. *Courtesy of Captain Larry Stokes. Photo by Jennah E. Smith.*

Connecticut General Assembly, it created a "Private and Special Law" to effect its legitimacy. The law gave the company the rights to "establish, maintain and operate a ferry across the Connecticut River between East Hartford and Hartford…from a convenient point below the Hockanum River to…Colt's Dyke." It was authorized and empowered to "operate said ferry by steam, horse, or other power that may be judged expedient."

The ferry servicing Colt's factory lasted into the 1880s. In a notable reaction to changing industrial dynamics, J.F. Ryan, a real estate developer, in 1930 suggested that the ferry be reconstituted. This manifestation would bring workers from the South End of Hartford and Wethersfield to the factories of Pratt & Whitney Aircraft and Chance Vought in East Hartford. He touted his plan on the merits that it would allow many people to essentially walk to work. He opined that it would also relieve congestion on the existing bridges during rush hour and save workers five or six miles on their daily commute. His seemingly good idea came to naught, however, and no ferry was forthcoming.

While many of the old ferries were family owned and operated, many were strictly commercial enterprises with no family ties whatsoever. The names of the two remaining ferries today reflect dynasties of family-owned and family-operated boats. The barge *Hollister* is named after a famous Rocky Hill–Glastonbury ferry family, as is the *Selden III*. The traditions of family ferrying are reflected in the stories of Jim Grant, who followed his dad onto the deck of the *Hollister*. Also, longtime captain Larry Stokes is connected to another Captain Stokes who ran the *Lady Fenwick* between Old Saybrook and Old Lyme at the beginning of the twentieth century.

Interestingly, the legislature sometimes granted privileges of primogeniture to ferry operators and sometimes it did not. For example, in 1811, it granted George Lord and Eber Rutly, their heirs, executors and assigns to "have, use and keep a ferry from East Haddam Landing to Haddam." The rights to the ferry were granted in perpetuity. Yet three years later, in 1814, Calvin Brainerd was granted the rights to a ferry at Haddam Island, but only for fifteen years.

The coming of steam propulsion marked the end of family-run ferries. The expense involved in purchasing, maintaining and fueling steamboats priced the small private entrepreneur out of the business. Ferries increasingly were operated by the governments of the communities they served, corporations and finally the State of Connecticut. The state took over the management of the two remaining ferries, Rocky Hill–Glastonbury and Chester-Hadlyme, in the early twentieth century.

CHAPTER 2

CAPTAINS

From the seventeenth century to the nineteenth, Connecticut River ferry captains were usually men who owned the boat and had access to landing places, either through ownership, lease or local government fiat. From Whittlesey in Saybrook, Bissell in Windsor, Chapman in Haddam, Brockway and Ely in Lyme, Warner in Chester, Smith in Rocky Hill and many more, the ferries were often family owned and operated. The early technologies of sail, oar, treadmill and cable certainly required boat-handling skill to navigate safely the currents, freshets, debris and ice of the river. But these were the technologies of the agricultural age. With the coming of the industrial age, the inherent nature of the ferries changed to adapt to the sociocultural revolution that transformed the river valley in a relatively short period of time. Steam! Some of the earliest steamboats in the world came up the Connecticut River. The harnessing of that power created the Industrial Revolution. The products of the region's expanding factories were added to cargoes of produce and draft animals. The ferries were quick to adapt.

Steam propulsion required a new set of skills. Mechanical systems required engineers to keep the paddle wheels turning and to prevent the whole shebang from catching fire or blowing up. Of course, they were not always successful, as the *Portland* incident described in chapter 5 points out. They also required a new approach to boat handling. Navigating a large vessel into a small slip under power was different than running a scow up into a cornfield or reaching a fixed destination on a cable. As a result, the

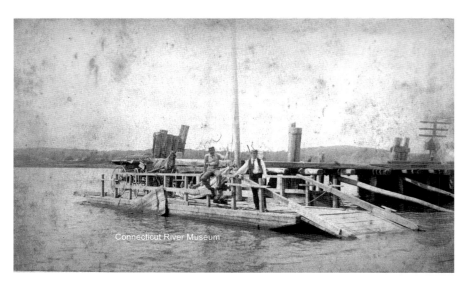

A couple of gentlemen relax aboard Ely's Ferry in Lyme. *Courtesy of the Connecticut River Museum.*

skill sets of steam ferry captains created a new cadre of officers aboard the boats. Engineers were now needed, along with men who were experienced in the handling of big boats with engines. Hence began a tradition of deep-water sailors transferring their skills and abilities from the rolling ocean to the flowing river. That tradition continues in the twenty-first century.

A classic example is Captain Joseph W. Merrill, who was born in Canton, Connecticut, in 1833. As a young man, he traveled to Mississippi to mechanize a sawmill that was owned by a gentleman from Hartford. He soon transferred his knowledge of machinery from woodcutting to wake cutting. He began a career piloting steamboats on Lake Pontchartrain, the Gulf of Mexico and the Mississippi River. In 1861, as the Civil War became inevitable, he brought a boatload of people with Northern sympathies up the Mississippi in hopes of returning to the North to enlist in the Union army. Ironically, his vessel was fired upon by Union soldiers as it made its way past Cairo, Mississippi.

Merrill returned to Connecticut to join the First Company, Twenty-Second Regiment, Connecticut Volunteers. He served admirably and was discharged in 1863. Upon his return to his home state, he applied for work at the Colt Firearms Company. Because of his previous nautical experience, Samuel Colt appointed him captain of the Union Company ferryboat that

carried workers from company housing in East Hartford to the sprawling factory on the west side of the river. After several years running the ferry, he took a position at the Collins Axe Company near his birthplace. He finished his career there, and the company president rewarded him with six twenty-dollar gold pieces upon his retirement. He returned to the South to live out his days in ease, coming to a peaceful end in 1916.

There were some reversals of the sea-to-river progression, however. Ruiz H. Hills began his waterborne career as a deckhand on the Colt ferry under Captain Merrill. He followed a sailor-to-officer career path, first being promoted to pilot and later to captain. He served in that capacity for several years, taking Colt's factory workers back and forth across the river he came to love deeply. His wanderlust—at least the Connecticut River version—got the best of him, and he transferred his ship-handling and command skills to the New York and Hartford Transportation Company. He spent many years as captain on towboats serving various ports along the river. He eventually was given command of the steamer *Middletown* that ran from New York to Hartford on a regular schedule. It was his privilege to enjoy the

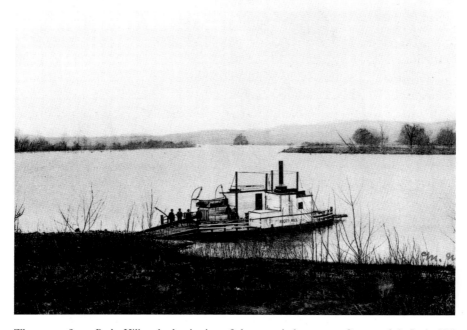

The steam ferry *Rocky Hill* at the beginning of the twentieth century. *Courtesy of the Rocky Hill Historical Society.*

golden age of steam travel on the river, and as captain, he surely had some enjoyable moments. But those moments were fraught with responsibility and danger. The lives of hundreds depended on him. He dealt with fog, freshet, wind, ice, snow and sometimes less than competent crew. But his service was exemplary, and he retired in 1921. Command of the *Middletown* then passed to his nephew Captain William Hills. Ruiz, however, was given an emeritus title of lifetime commander and spent his last two years ashore before a heart attack ended his days. According to the *Hartford Courant*, "It was said that no man living had a better knowledge of the Connecticut River than he….He had mapped out in his mind the location of every sand-bar on the river's bed." His passing coincided with the transition from steam to gasoline and diesel power for the river's ferries.

A bit farther downriver, during the 1940s, the towboat/barge operation at Chester-Hadlyme was under the command of Captain Charles Lamson, who made the transition from blue-water voyages under sail to guiding his tandem rig across the river. He was described as a "blue-eyed son of Maine… an affable, soft-voiced skipper, who wears a business suit and a fuzzy, fawn-colored, cloth cap." He took to the seagoing life at the age of seventeen and spent many years on schooners in the coastal lumber trade. He fondly recalled adventures in all the major ports from St. John, New Brunswick, to New York City. He traded his coasting life for one of an oysterman. That transition brought him to the Connecticut River.

At that point, he was the proud owner and master of a beautiful schooner. As fate would have it, the sleek craft became ice-bound off East Haddam one particularly cold winter. As the temperature plummeted, the ice grew thicker and impenetrable, trapping the vessel in its clutches. Eventually, the weight of the ice became so great that it crushed the hull of Captain Lamson's pride and joy, and the boat sank to the bottom of the river, damaged beyond repair. Unexpectedly on the beach, the bereft sailorman looked for opportunities to put his seagoing skills to work. He serendipitously encountered an official of the State of Connecticut, who hired him on the spot to fill the vacancy created by the retirement of longtime captain Jim Alger. (Alger was the source of a famous quip. In the early days of automobiles, he was asked how many cars his barge could accommodate. His legendary response to a skittish lady driving a Model T roadster was, "Madam, this ferry will carry five cars, or four Fords.")

Another ferry skipper who made the transition from sail to steam, and later to gasoline, was Captain Daniel W. Taylor. Captain Taylor was at the helm of the Rocky Hill–Glastonbury operation from the early 1920s to

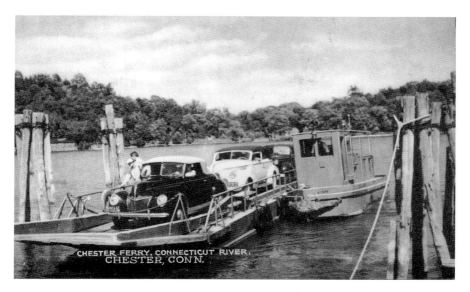

Five automobiles or four Fords aboard the old Chester ferry. *Courtesy of the Connecticut River Museum.*

the early 1940s. His life before settling down as a ferry master was full of adventure and hard work. He was born on Long Island Sound in the town of Clinton, Connecticut, in 1870. At the age of fourteen, he ran away to sea to serve before the mast aboard the schooner *Crises*, under the command of Captain George Beckwith. The primary function of that ship was on the Hudson River supplying Sing Sing Prison with cordwood loaded at a variety of East Coast ports.

He returned to Connecticut and transferred his able seamanship abilities to the brownstone schooners that carried the products of Portland's quarries to New York and Philadelphia. Taylor was promoted to second mate and took a berth on the *Freestone*, under fellow Clinton native Captain Lucius J. Stevens. The *Freestone* was engaged in the molding sand trade and made frequent voyages to Providence, Boston and New York. Taylor became familiar with the sailor towns of the East Coast and seemed set on the peripatetic life of a coasting mariner.

But in 1888, he made a surprising pivot in his career path. He enlisted in the U.S. Army. But even this usually landlubberly turn of events couldn't keep him off the water. Because of his seagoing skills, the army assigned him to take command of the boat that ferried officers back and forth from Angel Island in San Francisco Bay to the mainland. A soldier on salt water, he rose

through the ranks and eventually attained the rank of sergeant. At one point during his military hitch, he was transferred to Alcatraz Island. For a brief period, he was assigned the duty of guarding the great Apache Kaetena. He recalls the vanquished Native American as a "stubby, little fellow" who endured his imprisonment impassively and always grunted thanks when Taylor brought him his meals.

After his term of service was completed, Taylor returned to the Nutmeg State and was employed in a variety of land-based occupations. He worked for the fledgling Bell Telephone Company. He became a meat cutter, a mail carrier, a guard at the Colt Firearms factory, a town constable and finally the owner of a flourishing concrete business. While engaged in these endeavors, he supplemented his income netting and boning the shad that swim up the Connecticut River to spawn every spring.

It was this selfsame river that drew the tobacco-chewing Captain Taylor back to the water. In 1924, Charles Lamson, who later became the aforementioned skipper of the Chester boat, was piloting the old steamer *Nayaug* on the Rocky Hill run. Lamson was laid up with a leg injury, and Taylor was asked to fill in as an emergency replacement. The *Nayaug* was built in New London in 1903 by his cousin Arthur Taylor, who operated it for a few years. His temporary placement quickly became permanent, and Taylor had found his true calling.

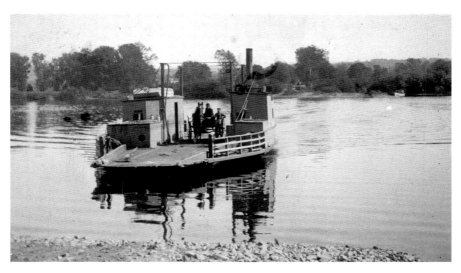

The ferry *Nyaug*. She steamed between Rocky Hill and Glastonbury between the nineteenth and twentieth centuries. *Courtesy of the Connecticut Historical Society.*

When he took command in 1924, it was still common for passengers to arrive at the ferry slip in a horse and buggy rig. There was a horn tied to a tree into which the would-be river crosser would blow a mighty blast to summon Taylor from the other side of the river. There were more horse-drawn vehicles than cars at that time, but the age of the automobile was making its presence known on the ferry exponentially. Barnyard animals were common aboard the ferry. The bleats of sheep and the moos of cows accompanied the oinks of pigs and the neighs of horses. The lambs and porkers went across for two cents, while the bovines and equines cost a nickel.

Within a few months of his taking the job, Taylor found the trusty old *Nyaug* replaced by a gasoline-powered towboat, *Selden*. It was later replaced with a tug named *Hollister*. That configuration provided the template of the operation that continues to this day. When Taylor took command of the ferry, fifteen cars a day would be considered a very busy time. But each year, more and more vehicles and trucks displaced wagons and buggies of yore. In the early days of gasoline power, five gallons of the flammable liquid would more than suffice for a day's ferrying. By the early 1940s, daily consumption often exceeded twenty-five gallons. Captain Daniel W. Taylor retired from the ferry service in July 1942 after twenty-four years running between the two central Connecticut River towns. He still visited the ferry to kibitz with the current captains and crewmen and reflect on a career on the water that encompassed fifty-nine years.

As the industrial age replaced sail with steam, twentieth-century ferry skippers cut their seagoing teeth under power before taking the helm of cross-the-river boats. Ben Hawkes, for example, who began piloting the Rocky Hill–Glastonbury towboat in 1978, received his master tugboat pilot's license in 1961. He towed barges up and down Long Island Sound for seventeen years. Unexpectedly finding himself on the beach in the late '70s, he answered an ad in the *Bridgeport Post* and soon after found himself in the wheelhouse of the *Cumberland*. As he put it, "I've been towing boats all over creation since I was a kid." He rose through the ranks to become senior captain with the Department of Transportation Bureau of Waterways.

His love of all things nautical spilled over to his days off. When he wasn't guiding his tow and barge from bank to bank on the river, he could be found at the helm of a forty-foot ketch as scoutmaster for a group of Sea Scouts in Southport. He loves the boating life because "there is always something happening, always something to fix. There's no road service [this was back before Sea Tow came on the scene] for anybody who drives a boat, so you

better know how to fix things. I can't keep away from the water; I see myself with boats for a long time."

Captain Hawkes knew that every trip across the river from Rocky Hill to Glastonbury is just a little bit different. He noted that most of the really hazardous situations occur during the summer months, when speedboats and water-skiers populate the water on sunny days: "Speedboats heading downriver are difficult to spot because of a sharp bend in the river less than one hundred yards north of the ferry route." He reiterates the age-old lament of professional mariners that in the modern age, not enough people who drive boats are aware of, nor do they obey, "the rules of the sea....It's like driving down I-95 when you're the only one who has a license."

The winter months also placed some obstacles in Ben's path. He noted that "that iron deck is slippery when it rains, and even slipperier in snow squalls. It took me a great deal of time to get my towboat license, so I don't want to risk it doing something dumb. Plus none of us feel like pushing a car stuck in slush off the deck." Increases in traffic because of construction on area bridges also present challenges because they put pressure on the captain and crew to cross as quickly as possible. Exigencies of the job aside, Hawkes loved being the captain. "As captain, you are your own boss. You either pick up all the marbles or you drop all the marbles. And that is worth its weight in gold."

Howard Lussen, who made a career of working on the ferry for thirty years beginning in the late 1950s, reinforces the hazards that pleasure boaters can be to the ferry's operation. After his retirement, Lussen refused to ever ride on a ferry again. It would make him feel like he was still working. "I'd be afraid that a water-skier would hit the boat." He added that the waters are a lot more crowded than back when he began his career. Overall, he felt his experience was positive. "I met lots of people from all over the world. I met several governors. I watched kids grow up. And I had fun doing it." He believed that the ferry should be free and open to the public. In his view, the operation had paid for itself many times over. "People who ride it today can relax, take in an ocean breeze and miss fourteen miles of accidents on the highway." He lamented that the price was high, though, at $2.25 per car and $0.75 per passenger. He lamented the drop from six-man crews down to four men.

One legendary twentieth-century captain had no prior maritime experience and "came up through the hawse pipe," as the old nautical saying goes, rising from green deckhand to commander. Along with his bushy beard and genial demeanor, Cap'n Dan had one of the best nicknames in the ferry

service. His full moniker was Dan Hamosovich, but he was known and loved by many as Captain Ham Sandwich. His career on the Chester-Hadlyme boat spanned over a quarter of a century beginning in the early '60s.

His affable demeanor helped him talk his way into a job with the ferry service. "To become a ferryboat operator, you should have some form of boat-handling experience. When I first got here, I didn't know too much about boats. If you asked me which end was the bow, I would have said, 'Well, I don't know. Which one is it?' I never knew 'til I got here." That would have been a bit of a trick question, though, because the *Selden III* is double ended and has two bows. He spent his first year aboard as a deckhand learning the ropes and figuring out which end was which.

He learned all aspects of boat handling, as well as mastering knowledge of all the mechanical systems and maintenance duties necessary to keep his vessel chugging across the river. He received his captain's license from the Coast Guard and renewed it faithfully every five years during his tenure as master. He proudly displayed it in the wheelhouse of the *Selden III* and would not hesitate to point it out to visitors in its place of pride on the wheelhouse bulkhead. "Yup, that's mine right there," he beams. "It says right there, licensed to operate or navigate passenger-carrying vessels."

Captain Ham Sandwich points out that there are more responsibilities to being skipper than just getting his passengers from one side of the river to the other. "We are responsible for the entire maintenance of the vessel," he explains. "In the winter months, we chip the paint and repaint and do any necessary repairs. If there are big repairs that need to be done, we take the vessel downriver to whichever boatyard had the contract to do the work. This ferry was built in 1949, and the only time we had a real problem with it was in 1985 or so. We found a little pinhole in the hull. It's a sound vessel, and as far as I'm concerned, that's pretty damn good."

Most of the time, he relates, the crossings are fairly routine. But the wind, waves, fog, ice and snow can occasionally present challenges to his boat-handling skills. "It can get really rough out there. One time, what is usually a five-minute crossing took us over an hour because the river was so perturbed. We had only one car on deck that time, and we made sure all four wheels were blocked good. When we finally got to the other side, that car had moved about five feet across the slippery deck."

He allows that the job could be boring if driving the ferry were as simple as driving a car. "The road you drive your car on is solid; it never moves. The road I operate this vessel on is always moving. The forces are working against me, and it's a continuous fight against Mother Nature. She can be ornery at

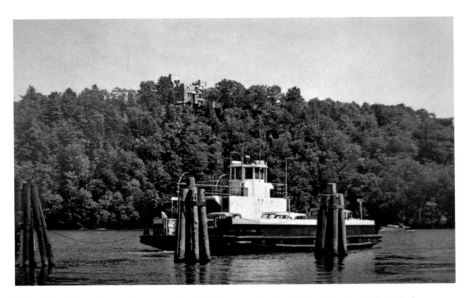

The *Selden III* eastbound on an early fall afternoon in the 1950s. *Courtesy of Captain Larry Stokes. Photo by Jennah E. Smith.*

times. She can fool ya." After his retirement, Captain Ham Sandwich hoped to explore more solid roads, as he and his wife plan to travel cross-country in a motor home. But before he "swallowed the anchor" and headed to shore permanently, he could always be found in his beloved wheelhouse—a handmade visor on his head, his sunglasses perched on his nose, a sharp eye on the shoreline and a steady hand on the wheel.

Leon Baldowicz, who shared captain's duties with Ham Sandwich, was, naturally, known as Baldy, although he sported an almost full head of hair. He developed his sea legs in the navy and the merchant marine. He spent several years on old barges and tugboats before finding a permanent berth on the Chester-Hadlyme boat. He thoroughly enjoyed his work. "It's not hazardous, but it's far from boring. Every crossing is different. Conditions are always changing due to tides, currents and other river traffic. It is a pleasant job. We meet interesting people and enjoy wonderful scenery." Baldy made an interesting economic observation when he surmised, "Ferry use increases when times are bad, because people stay closer to home."

In the late 1990s, the wheelhouse of the *Selden III* was the domain of the captain with the most famous name of all those who piloted the boat. John F. Kennedy could be found at the helm in fair weather and foul. He had cut his nautical teeth on oceangoing tugboats. His adventures took him up

and down the Atlantic coast from Virginia to Maine and gave him the skills necessary to get his master's ticket and take command of the ferry. He, too, spoke of the uniqueness inherent in each crossing of the river: "There's no room for daydreaming on this job. River currents, tidal flows, eddies and shifting winds make every one of the trips on my shift different. If you can run this ferry, you can run anything. There is so much that happens on this ride that I have to keep my own navigation notes. No book can cover it all."

Sharing command with JFK at the time was Captain Joe Cheeke—not exactly a historical name but one that could be part of a pun or two. Like several of his peers, Joe began his career as a deckhand on towboats and barges, primarily on the Gulf of Mexico and up the Atlantic coast. He transitioned to ferryboats, working first in Miami and later Mississippi. He is quite effusive in his praise for his captaincy of the Chester-Hadlyme ferry. "It's just gorgeous," he enthuses. "I feel like I died and went to heaven. It's the first job I've had where I'm really glad to come to work every day. On my worst days, it's better than anyone else's job." He has the usual complaints about recreational boaters who don't realize it takes time for him to stop; he terms them "nuisance traffic." But the view from the wheelhouse makes it all worthwhile. "It is one of the prettiest rivers you will ever see." He likes that most of the passengers are pleasant and often bring along cookies, brownies and other munchies to share with the crew. He laments that they can sometimes "get huffy" during summer waits. But day in and out, the job is the best.

John Marshall, the master captain of the Chester-Hadlyme ferry, as of this writing, certainly agrees with Cheeke's assessment of the river's beauty. "Every day, I am in awe of what a resource this river is. Especially in the fall. I look down toward Selden Creek and it's just, 'Gad! Am I lucky, or what!'" Marshall, like many of his predecessors, began his career on commercial boats. He started out in Alaska but returned home to Connecticut and took command of the ferry. He prefers the quotidian routine to the occasional excitements. But he knows that it is never a good idea to become complacent. Too much can happen too quickly, especially because there is very little water at either landing spot.

He thinks that the 1949 Warner-designed, Luders-built *Selden III* is the ideal boat for this particular part of the river. If he were to get a new boat, he would hope it would be just like the current model. "It really does the job!" As he looks back on his twenty-year career, he remarks on a couple of major changes. "When I first started, there were big barges and tankers coming up the river on a regular basis. With little room to change course, we would have

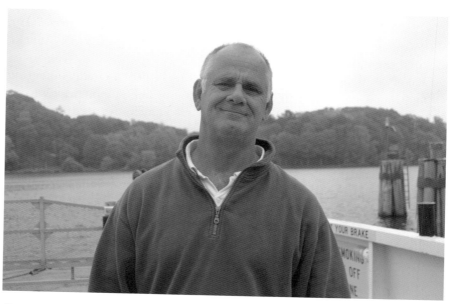

Captain John Marshall aboard the *Selden III*: "Every day I am in awe of what an amazing resource this river is." *Photo by Jennah E. Smith.*

Selden III at her winter quarters in New London. Note the wooden stairs to facilitate access to the wheelhouse. *Photo by Jennah E. Smith.*

to communicate by radio to make sure everyone was on the same page." The other change he noted was the rise of SUVs. The bigger, heavier vehicles required changes in loading strategies and fuel consumption.

One of the things Marshall likes about his job is the seasonality of it—the spring freshet, followed by the summer tourist season and then the gorgeous display of fall colors as the river puts on its annual array of beauty. Holidays are a treat for John. He enjoys "dressing ship," putting up the ceremonial flags that mark days of calendric importance, such as Memorial Day, Fourth of July and Labor Day. There is a tradition of the crew dressing for Halloween and distributing candy to young passengers. At the end of the season, Christmas lights and a tree often grace the boat, and Santa is likely to put in an appearance replete with elves and carolers.

There are three ferry masters whose careers spanned the end of the twentieth century and the beginning of the twenty-first. John Marshall is one. Larry Stokes exemplifies this particular cohort of captains. He started running the Chester-Hadlyme boat in 1990 and quickly transferred up to Rocky Hill–Glastonbury. His business card identifies him as "Master of Towing." Prior to joining state service, he was employed offshore, towing Sea-Land containers over several oceans all the way from Davisville, Rhode Island, to Tierra del Fuego at South America's southernmost tip. He returned to his home state of Connecticut and used his seagoing skills to find work aboard ferries out of New London. He carried people, animals and equipment across Long Island Sound. The mysterious Plum Island, whose biological research facilities are still the subject of conjecture and conspiracy theories, was one of his ports of call.

Larry was painting a large vessel in a New London shipyard when he heard about a vacancy on the Connecticut River ferries. He claims that it was the "fickle finger of fate" that guided him to the wheelhouse of the *Selden III* and eventually a long and distinguished career on the river. Captain Larry thinks that the challenges presented by boat handling are the most interesting and important part of his job. "It has been enough to keep me interested in crossing the river for all these years," he reflects.

Like many others who work on the ferries, Larry likes the interactions with passengers. He finds it amazing that people from other parts of the world consider Rocky Hill a specific travel destination because of the ferry. Over the years, he has met several Europeans who flew into Boston rather than New York for the express purpose of riding the ferry. He has befriended passengers from all over the globe. One day, he got to talk to travelers from Sweden, New Zealand and Australia. Their interest in

Exterior of the wheelhouse of the *Selden III*. Note the mural that was added during the great advertising kerfuffle. *Photo by Jennah E. Smith.*

the ferry reinforces his belief that it is an important piece of American history and culture.

Another century-spanning skipper is the redoubtable Captain Jim Grant. For Jim, commanding the ferry was not just an avocation, it was a lifelong passion. Ferrying was in his DNA. His dad worked on the Rocky Hill boat for years. When he left the boat to take a position with the railroad division of the Department of Transportation, Jim followed him aboard. He had a knack for engines and machinery, which came in handy as the miles on the tug added up. Over the years, he piloted both of the remaining ferries on the river. His love of the boats inspired him to devote much of his retirement time to researching their history and the stories of the bygone boats of yore. Once asked why he did what he did, Jim responded, "I'm here because I love my job. I love what I do."

That love for his role as ferry captain began at a very young age. "When I was a child, my grandmother would walk us down from Wethersfield, and we would ride back and forth on the ferry. We would have wonderful picnics on the rock pile on the Glastonbury side. We would walk up the road to the farm and pick strawberries. We went back down to the ferry and petted the cows that would be grazing at the ferry slip." He recalls being a

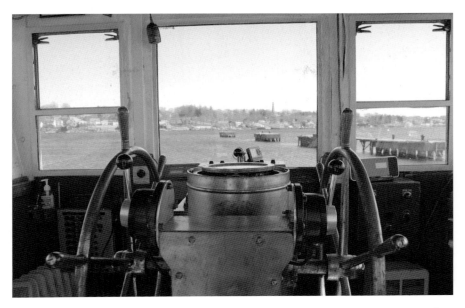

The interior of the wheelhouse of the *Selden III*. She is docked at her winter quarters at the state pier in New London. Note Fort Griswold across the Thames River in the background. *Photo by Jennah E. Smith.*

young boy and bringing his father, the mate and Captain Wittick a plate of food every Thanksgiving while they waited for passengers that were few and far between. Captain Ben Hawkes pointed out that it was economically unsound to run on that holiday, since two crews were paid double time and there was very little business.

The ferry business was much more relaxed when Jim was a lad. He reflects that when he started as a deckhand due to a spot opening up because of a promotion, "Arthur Hale was a captain, and his wife ran the Pilot House [a small walkup food shack next to the ferry]. The Hales lived in a house right at the ferry slip and also operated a small marina and ship's chandlery. Captain Hale would often get off the boat and hold up the ferry to sell some paint at the ship's store, gas up an outboard or sell a can of worms to a dad so he could take his son fishing. Coast Guard licensing was often grandfathered in, and the ferry was pulled out on a marine railway right next to the Pilot House."

In the early days of his career, Jim and his fellow crewmen were mandated by the state to wear hand-me-down, heavy scratchy wool uniforms that had previously adorned the guards at the Connecticut State Prisons. As the heat

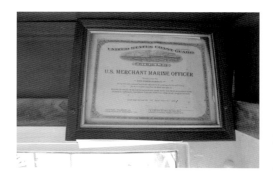

Captain John Marshall's Coast Guard license, which allows him to operate the *Selden III* and carry passengers. *Photo by Jennah E. Smith.*

of the summer increased, more and more captains and crew foreswore this hot, itchy attire and adorned themselves with more comfortable khaki outfits with an official-looking state badge at the shoulder. According to Jim Grant, only one of the older captains, Bill Wittick, wore his wool uniform day in and day out, regardless of what the thermometer might be reading. As social customs changed, crew members could sometimes be spied wearing— gasp!—shorts.

As time went on, though, things got a bit stricter, with the state tightening things up. In 1977, the ferry crew was assigned to the toll division of the highway department. Instead of performing maintenance on the towboat and barge in the winter months, crew members were counting toll tickets on the bridges. In 1979, they returned to the boatyard to work on the ferry all winter, but in 1982, winter work plowing snow was instituted to offset the cost of running the ferries. The mates were required to attend driver's training and get Class 2 commercial licenses to allow them to drive the snowplows. Winters also found him and his fellow ferrymen on state highway bridges collecting tolls and counting tickets.

In 1982, Jim received his license to command the *Cumberland* and carry passengers. Through retirement-driven attrition, he was promoted to captain in 1983. In 1996, he was offered the position of lead captain on the Chester-Hadlyme boat. He calls the operation of the *Selden III* as " very tricky….It is powered almost all the way into the dock and relies on a heavy reverse thrust to steer into the landing and stop." The barge and towing operation in Rocky Hill presented a different set of challenges. The practice called "towing on the hip" requires the captain to "back down so you have enough swing for the pull on the bow line to draw the barge to the front of the tug. This is why we angle into the current and back down from about a sixty-degree angle. When the tide is running in at low water, it will throw you to the north, and when the freshet is strong, you need to power into the

slip, using the current and reverse starboard rudder to try and keep off the dolphins. That angle of approach is commonly called a crab angle."

When asked to share some of his favorite stories and memories from his days on the ferry, Jim conjures up the story of Walter Kellam, the blind lamplighter. Kellam lost his sight, and to help support his family he would maintain all the kerosene-burning navigation lights on the east side of the river from Glastonbury up to Keeney Cove in East Hartford. With the aid of a cane, he would walk to the river's edge every morning, clean the lenses and refill the lamp oil in all the navigation lights. Those lights were very important back in Kellam's day because of the frequent barge and tanker traffic bringing petroleum products up the river to Hartford. Captain Hollister, who was a neighbor of his, at times of high water, would give the lamp man a ferry ride up past Roaring Brook so he could complete his important tasks.

As far as memorable events in Jim's career are concerned, of course, they were many and varied. He likes to tell the story of the time the Rocky Hill ferry debuted as a rock star. In 1991, the musician Billy Joel requested that the state give him permission to film a segment of the video for "River of Dreams" on the ferry. The response to him was long and convoluted, full of government bureaucratic jargon, but in essence said it was okay, as long as it didn't interrupt the daily passage of the ferry. Jim claims that Christie Brinkley, the singer's wife, painted the image for the album cover on the Glastonbury side, on the peninsula looking toward the Rocky Hill Meadows. (Interestingly, people involved with the Chester-Hadlyme operations claim she painted on the Chester side, looking over at Gillette Castle.)

Be that as it may, the video was shot. Jim became "the captain that is mysteriously filmed behind the piling, pulling out to get a car over in Glastonbury. Even though we signed releases, as part of a state landmark, we were purposely avoided by the cameramen. The images of kids asking me to blow the horn wound up on the cutting room floor. The ferry was featured in the video, but we never got to see Billy Joel. Ironically, his boat, *Alexa Rae*, was right behind the tug *Cumberland* at Essex Boat Works when they both were hauled out for the winter. We saw him roaring out of the boatyard in a Ferrari that spring."

When reflecting on his years crossing the river, which began in 1979, Jim compared himself to some of his peers and predecessors. "For some, it was just operating a piece of equipment. The equipment operation was important, of course, but it was secondary to the big picture." The burly, bearded, ebullient, retired ferryman continued: "For me, it was a social and

interpersonal exchange. It was all about the people. I can honestly say that on most days, I loved my job and my customers." For that reason, Jim preferred running the Rocky Hill ferry rather than the Chester boat. It gave him more opportunity to interact with the passengers on board. Be they regular commuters or once-in-a-lifetime tourists, Captain Grant was always willing to give them their money's worth. If it was an early morning commuter run, he would zip across the river to help his charges get to work on time. If his deck was full of tourists, he would take a leisurely route across the river, regaling them with history and river lore as they enjoyed their passage.

Often, the job had some excitement or social significance attached to it. For most of Jim's career, oil barge and tanker traffic was still heavy on the river. He reflects on "more than one close encounter when a barge came around the bend at dusk in the fall. Special events, like Sunfish and raft races, often filled the river with small craft that made maneuvering difficult. We nearly rammed the boat that was providing rides for the Rocky Hill Strawberry Festival when our steering ram broke. In 1993, we carried the Special Olympics torch across the river. We had a guest book at that time, and all the kids signed it."

Captain Jim was always willing to use his ferries as tools to educate the children of Connecticut. Children from Glastonbury would ride the ferry as part of a school project, and Jim would "paint a verbal, visual picture of a single, flat side-wheeler loading coal first thing in the morning at the coal dock, squeezing in between river tugs and barges loading vegetables and coal for the trip to New York. When it got back to its slip, there would be a line of farmers' wagons waiting to take their goods to the train station up the road from the ferry to ship produce to the farmers' market in Hartford."

In the early 1980s, this author wrote a children's book, with kids from the

Captain Jim Grant dressed as Braveheart with local TV personality Dan Kane. Grant initiated Halloween and Christmas activities on the ferries as a way of saying thank you to regular customers and boosting public relations. *Courtesy of Captain Jim Grant.*

New Britain Head Start program featured in the book to promote literacy. The story involved their school bus having an adventure on the ferry. Jim Grant graciously welcomed our students and their bus on board and made a long loop on the river, acting out the story for the children.

In 1995, Jim introduced Halloween on the ferry as a way of thanking customers for their patronage all spring and summer. Also, ridership was down and the state was grumbling, once again, about shutting down the ferry service. He thought it would be good public relations to generate some awareness of the ferry and have some fun at the same time. He bought a couple of boxes of coffee and some doughnut holes for the adults and some candy for the kids. In an elegant pirate chieftain's outfit, what he termed a cross between Captain Hook and Captain Morgan, he welcomed passengers onto the ferry that was flying the Jolly Roger in place of the Stars and Stripes. As he puts it, "By the time the state found out about it, it was on the evening news." Area media was enchanted with the idea, and the images and the event became a yearly staple on local television.

Never one to miss an opportunity to play dress-up, he introduced the practice of celebrating Christmas when he was on the Chester-Hadlyme boat. The state began to see the publicity and community engagement benefits from these types of activities and actually gave Jim a budget for candy and decorations, after he provided them out of his own pocket for a few years. Replete with carolers, twinkling lights and red and green–clad elves, the ferry was transformed into a floating Santa's village, designed to spread good cheer across the river. The state money came with a catch, however. It gave him a Santa suit on the condition that he play Santa at Bradley Airport. He arrived on the tarmac on a fire engine—one of the few Santas to travel that way, and on a ferryboat and sleigh, too!

Captain Jim Grant dressed as a blend of Captain Hook and Captain Morgan. The *Cumberland* flew the Jolly Roger in place of the Stars and Stripes that Halloween. *Courtesy of Captain Jim Grant.*

Santa, of course, was played by the doughty captain. He recalls a couple stories that gave added meaning to his job and his avocation as Santa. One year, a little girl who had been adopted from Russia only the day before wound up on his lap. She had only seen the jolly old elf on grainy black-and-white TV and was entranced by St. Nick live and in color. When it was time to leave, she resolutely clamped her arms around his leg and refused to go anywhere. "Please, Santa, let me stay. I will be good! I will eat my vegetables," she entreated. Finally, she let go and went off to new adventures in the United States of America.

A more poignant tale occurred when Jim was asked to go over to a van and be introduced to an eight-year-old girl who had never seen Santa. With his son behind him bearing candy canes, Captain Grant approached the van, and the girl's mother explained that her daughter was blind, and every attempt to visit Santa in the past didn't end well when she grabbed the imposter's fake beard. He said, "As I stood there, she explored my face with her hands and said, 'You have dimples and round cheeks, just like the book says!' She said that I had a real beard, with some fuzzy stuff on it. She patted my belly and felt my patent leather belt. She said it was so smooth, it must be shiny, just like the book. The ferry reached Hadlyme, and she touched my heart. As they drove away, I turned to my son and told him that I didn't need anything for Christmas this year. I wiped away a tear and gathered my composure for the next customer. Some of the best gifts come from giving."

As our interview was winding down, he said there was one more anecdote that he would like to add. In the '80s and '90s, there was a tourist boat that sailed out of Hartford named the *Lady Fenwick*. It was a beautiful reproduction of a Herreshoff steam yacht and a very pleasant place to wile away a sleepy summer afternoon. It turned out that Steven Lee was the name of the captain. As the *Lady Fenwick* approached the ferry route, Lee and Jim would get on the radio and adjust their courses for clear passage. It was a never-ending source of amusement to him that Grant and Lee were finally speaking to each other.

Another skipper whose career spanned two centuries is Tom Darcy. Scheduled to retire at the close of the 2017 season, Tom grew up on the banks of the Connecticut River in the town of Deep River. It was once home to hell-raising Scandinavian and Irish quarrymen who worked the rocks on Selden Island by day and Deep River's gin mills by night. Tom was the youngest of five children of Irish Catholic parents. An older sibling once asked his father if Tom was a mistake. Without missing a beat, the quick-witted patriarch replied, "You were all mistakes."

Captain Tom Darcy inspects the deck of the *Selden III* at the state pier in New London. *Photo by Jennah E. Smith.*

But it was no mistake that Tom was drawn to a lifetime spent on the water. He joined a Sea Scout group, referred to as a ship, and found that sailing small boats on the river and Long Island Sound was just about as much fun as a young lad could have (at least with parental approval). He experienced his first and only bout of seasickness during his Sea Scout tenure off Bell 8, which marks the shoal that spreads out from the mouth of the river. It was a good thing that he wasn't prone to further forced trips to the rail, because he graduated from Sea Scouts into the United States Navy at the age of twenty-two. He spent ten years in the navy, mostly serving on destroyers. Known as "tin cans," they are noted for pitching and rolling. They wouldn't be a good match for someone prone to mal de mer.

In his thirties, back on the beach, Tom kicked around at various jobs. He was working as a maintenance man at a convalescent home when an offhand remark from a friend alerted him to the fact that a deckhand position was open on the Rocky Hill ferry. Given his seagoing experience, he was hired on as a crew member. He spent a week absorbing the routines and procedures that covered basic safety, bilge pump operation, fire drills, line handling and a general orientation to the vessel. He served his apprenticeship as a deckhand, but he knew his ultimate position would be up in the wheelhouse as a captain.

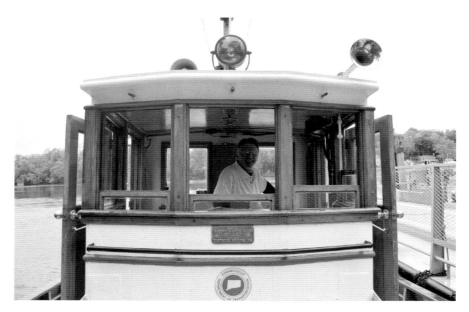

Captain Tom Darcy preparing to leave the Glastonbury slip to pick up passengers on the Rocky Hill side. *Photo by Jennah E. Smith.*

He remembers, "When I got up there [the wheelhouse], I was forty years old. The real skills you need to operate the towing on the hip style can't be taught. You can either do it or you can't. Fortunately, I could. I got my ticket and became a captain." He was transferred to the Chester boat for many years, and for his final season he is doing one last tour of duty up in Rocky Hill. He looks forward to a new life as a retired guy living down in the sunny South. When Darcy looks back on his career on the ferries, he is candid about some of the systems changes that he saw in his years commanding both boats.

He reflects that a "good captain makes it look easy. It is like a swan gracefully gliding across a glass-like river surface, but under the water there is a lot going on." The goal of the ferries is to get people across the river safely. But there is a whole hierarchy of administrative and operational structures necessary to accomplish that objective. For years, Tom crossed the river with the shadow that each crossing could be the last if the state government opted to shut down the service. During the last existential threat to the ferries, Darcy and his fellow captains became celebrities in the lower Connecticut River Valley, as pro-ferry partisans rallied and railed to influence legislators.

Darcy agrees with Jim Grant that there is a dichotomy of ferry clientele, commuters and tourists. "We try to get the commuters across the river as soon as possible; they have to get to work. You get to know them on a daily basis, and the interactions can be fun, and they sometimes bring a hot cup of coffee and a scone to share with the crew."

This author was part of the fun one August morning in the early twenty-first century. Now that Tom is retiring, it is a story that can finally be told. A group known as the Connecticut River Drifting Society made an annual canoe camping pilgrimage down the river every year. We camped at the park next to the ferry landing on the Hadlyme side, below Gillette Castle. A high-spirited and fun-loving crew, we were prone to hilarity and hijinx. In those days, there was a large cruise ship, the *Camelot*, that took day-trippers over to Greenport or Sag Harbor on Long Island. She would make her way up the river well after sunset, casting the beam of her searchlight about to see the buoys and day marks.

We, at our campsite after dinner, usually relaxed with an adult beverage or two on the riverbank. One year, it came into our collective heads to line the shore as the *Camelot* approached and give a loud *rrooaarr!!* to announce our presence and proceed to "shoot the moon," exposing our nether parts to the passengers aboard the cruise ship. This quickly became a tradition. The *Camelot* captains would watch for us every year and shine the bright beam of their searchlight on our aligned behinds as she sedately passed by. The usual reaction was loud cheering from the surprised day-trippers.

As fate would have it, an East Haddam doctor, a regular commuter client of Captain Darcy, happened to be aboard the *Camelot* one evening and was an unwitting witness to our semi-sordid spectacle. He related his view of events to Tom and a few other regulars the following morning. A plot was immediately hatched to exact revenge on the mischievous mooners. Instead of heading directly across the stream to convey his commuters to Chester, Darcy headed the *Selden III* upstream, hugging the Hadlyme shore. As he approached the Drifters' campsite, which was sluggishly stirring after late-night revels, he blew a long blast on the ferry's loud horn. The startled campers looked riverward to see Tom and four of his passengers up on the rail of the wheelhouse, pants around their knees, returning the lunar salute, to the amazement of all ashore.

Of course, that was a bit out of the ordinary, even for Tom. He would average fifty to sixty crossings in an eight-hour shift. "In the course of a year," he ruminates, "the *Selden III* covers the distance from New York to Rio de Janeiro." He, like many other captains, agrees that the most frequently

asked question over the course of a season is: Doesn't it get boring? Like most other captains, he answers:

Hell no! Each crossing is different. The winds, the tides, the currents, the knurls of water all make each run unique. And the parade of people that roll across our decks are sources of endless fascination. If I ever got bored with my job, I would have been out of there in a heartbeat. I have the best office view in the state from the wheelhouse of the Selden III. *There's a lot of responsibility, too. People's lives are at stake. Not just the ones on the ferry, but those on pleasure boats on the river as well. We get Jet Skis, speedboats, canoes, kayaks, water skiers, you name it. They usually, but not always, stay out of the way.*

We call it the tonnage rule. Eighty tons of steel versus a couple hundred pounds of fiberglass. Who will win that one? Many times, lack of experience and/or disregard for the rules of the road and safe boating will put people at risk. For example, I watched a family, mom, dad and two kids, carefully load their canoe full of gear and get into the water at the boat launch and cast off. Almost immediately, they were swept up onto the rocks by the wakes of powerboats. This can create quite a turbulence on a

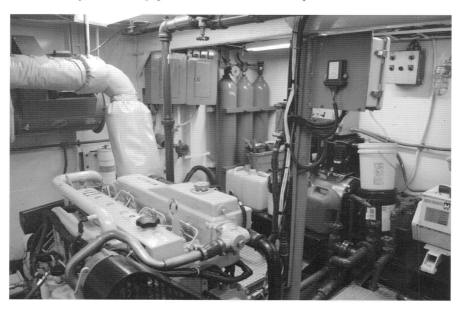

The engine room of the *Selden III*, looking shipshape and Bristol fashion. *Photo by Jennah E. Smith.*

summer afternoon. We stopped the ferry and came to their rescue. It was the first time they had ever been in a canoe. I suggested they might try a pond until they get used to it.

With safety as his top priority, Tom believes that boat handling is the most critical part of the job.

With a four- to five-foot draught, there can be some surprises. Especially in Rocky Hill, where the sand shoals are constantly shifting and the tides and currents can create boils of water that come out of nowhere and change the depth with no warning. In Hadlyme, the tide changes every six hours and twenty-two minutes, but in Rocky Hill, there is seven hours of ebb tide and three and a half hours of tide in flood. The currents always speed up and slow down around pilings and dolphins, so there are always challenges to navigation.

Three knots an hour is the normal speed for a summer tide in Rocky Hill. You have to make a loop downstream to find the deep water to get across. The dolphins and pilings in Rocky Hill have a lot of scrapes and dings. It is very often necessary to use them to help your docking and leaving. In Rocky Hill, I try to bump it in and out of gear to land as gently as possible. In Hadlyme, you have to come in a little hot. Ideally, you don't want to touch the dolphins there. Landing is always the most challenging part of the job. One Aw crap! *beats a thousand* Atta boys.

In the last decades of the twentieth century, one captain stood out as a symbol of the social changes that were occurring across the country as the interplay of family and economics evolved. They were known at the time as WINTOS: women in nontraditional occupations. Jobs that were the bastions of male power and privilege faced challenges from women who demanded inclusion in the old boys' clubs. Firehouses, police stations and construction sites all saw the coming of female pioneers who opened workplaces and set standards for the future. The Connecticut River ferries were no exception. In 1988, Cathey LaBonte came aboard the *Selden III* as a deckhand.

She wasn't a complete stranger to the male-dominated workplace. Prior to taking up the ferrywoman's life, she worked as a carpenter at Electric Boat, involved in submarine construction. Her first few trips across the river were a bit rocky—literally. The wakes thrown up by powerboats caused just enough bumpiness to give her a touch of mal de mer. But she quickly developed

her sea legs and progressed through the ranks from deckhand to mate, and ultimately, she took over the wheelhouse after passing her license exams. Her ex–Coast Guard veteran father was as thrilled as she was when she earned her promotion. She was particularly thrilled that she now outranked him.

It wasn't always easy, though. While her crewmates, for the most part, were welcoming and supportive, when she made the jump to captain, her regular commuter customers sent up many pointed remarks about female drivers. (One of the outdated stereotypes in those more gender-biased days was that women couldn't drive as well as men.) While most of the comments were delivered in a jocular manner, there were several men whose sensibilities were somehow set askew by a female at the helm. A few passengers would look up and wonder what kind of a ride they were going to get. After a while, things settled down, and she became just another boat driver in the wheelhouse.

There were still some societal differences though. Comparison of newspaper articles written about her and those that describe male captains is quite interesting. She is the only one who ever had her children mentioned. Perhaps, at the time, women's primary identity was still that of mother. There is mention of the day she received her captain's stripes and her husband and two sons greeted her at the door, standing at attention and saluting. Her boys called her Captain Mom for a few weeks until the novelty wore off and it was "Hey, what's for lunch?" as usual.

The old-time captains and regular commuters accepted Cathey, as she proved her mettle guiding the sixty-five-foot *Selden III* into her berth. Leon Baldwicz admired the way she could "romance the boat in, with a little tap here and there. It's OK to do that." She impressed several commuters not only with her "dead-on docking abilities, but also with her friendliness." Chatting with passengers was one of the parts of the job she enjoyed most. She tagged many of them with nicknames. Interestingly, she found it easier to identify regulars by their cars rather than their names. She loved her job because of the "fresh air, sunshine and people. I always tease that I get paid for tanning, socializing and taking people's money."

While most of her passengers, especially the regulars, were nice and fun, a few treated the crew like they were servants. "The jerks I used to park under the shelter deck so they would have no view." Sometimes, passengers got to experience the river up close and personally.

On summer weekends, we got a lot of boat traffic and wakes. If you hit them just right, you could goose the engines and make the front end dip

The *Selden III* approaching the Chester slip. Note the discreet advertising posters in glass cases. *Photo by Jennah E. Smith.*

down. Water would pour up over the deck and get people wet. The old-time captains called it "washing the decks." I called it "dance for me, gringos." Most people were nice though.

One fellow used to bring his wife flowers every month on the anniversary of the day they met. One day I teased him that he didn't have to bring me flowers. After that, his wife got eleven roses a month and I got one. He and his wife liked me because I stopped his chin from bleeding. He just bought a moped and tried to stop and smashed his chin on the handlebars. He was on the way to the emergency medical clinic, and I cleaned him up. I wound up looking like an axe murderer, but my good deed for the day was done.

Cathey loved being up in the wheelhouse. "I had a way better view than the governor did from his office. We had eagles, herons, giant snapping turtles, beavers and muskrats. Lots of shipping traffic to see. Tugs, barges, tankers and occasionally a USCG buoy tender. Lots of powerboats and canoes. Not too many kayaks back then. One lady had a rowing shell she took out most mornings."

Her all-time favorite memories are those of Katharine Hepburn, the elegant film star who lived in the Fenwick section of Old Saybrook. Hepburn

Captain Tom Darcy shortly before his retirement from the ferry service: "I hope I can bring my grandchildren here in twenty years and the boat will still be running." *Photo by Jennah E. Smith.*

would drive down to the Hadlyme ramp and blow her horn to announce her presence. "We used to wear khaki uniforms, and I wore my striped shoulder boards. Miss Hepburn used to ask me in her heavy New England accent, 'Deahhhhh, are you the captain?' I would reply yes, and she would pat my hand and say, 'Good for you, deahhhh, good for you.'"

Morley Safer, the late host of CBS's *60 Minutes*, was also a regular customer. He would climb the ladder up to the wheelhouse and chat with Cathey. He liked to talk about the various commercial ships that came up and down the river. And he was a great fan of the wildlife. "The sunrises and sunsets in the summer were spectacular. I was privileged to do such an important job in such a beautiful place."

As the twenty-first century lurches into its third decade, most of the captains who worked through the millennia are retired or about to retire. Given the investment that the state has made in upgrading engines, mechanical systems and docking facilities, there has been surprisingly little talk of eliminating the service, although a looming state budget crisis of catastrophic proportions could change that dynamic at any time. It is interesting to note, however, that the captain's job today remains, on principle, the same as it was centuries

ago. The object is still to get passengers, vehicles and cargo from one side of the Connecticut to the other. As Captain Cathey LaBonte so aptly put it, "The weight of responsibility of getting ten cars and ten people across the river can be heavy."

AN INTERLUDE:
SHAD MORNING ON THE OLDEST
CONTINUOUS CROSSING

by Stephen Jones

In America, nostalgia for things is apt to set in before they go.
—Robert Hughes, "The Decline of the City of Mahoganny"

Nevertheless, it may be best to indulge at times in a little bit of preemptive nostalgia. Toward that end, I traveled by car with a small film crew in May 2017 to the nation's oldest continuous ferry crossing. It was here, more than seventy years before, that my father had introduced me to the business of boats and water that became the mainstay of my life.

It is the nature of crossings on the bends of rivers to present unequal banks, a function of how the waters flow, what they carve and what they leave for people to build on. No better example exists than at the nation's oldest continuous crossing, which runs between the long, alluvial water meadows of South Glastonbury and the abrupt traprock ridge at Rocky Hill ten miles below Hartford on the Connecticut. While waiting alone for the ferry to detach itself from the far bank toward dusk, I find there is sometimes an eerie feeling brought on by the knowledge that in the Carnian age of the Late Triassic, twenty-foot lizards with serrated teeth were thunder-footing about here in the then gooey warm basalt before the Mesozoic floodplain covered their tracks.

It is maybe harder to imagine that here in 1655, prior to even their founding as towns, the settlements of Rocky Hill and Glastonbury, the locals actually poled a raft across the river. They later improved performances against strong currents by rigging up a horse-driven treadmill where the animal's mindless plod after its pail of oats was somehow geared into a differential that turned the axle of a paddle wheel. Even with the horse, there must have been many days when the current was yet too strong. It wasn't until 1876 that somebody got steam power to replace the horse and crossings could be made in all but the days of the spring freshet.

For a long time now, however, this has been the stretch of the Connecticut known to most impatient boaters as "the uninteresting part." They are anxious to leave the flat Mississippi windings behind for the straighter Rhineland reaches below Middletown with the Salmon River, Seldon Creek, Hamburg Cove, Goodspeed Opera House, Deep River, Hamburg Cove, Essex, Saybrook and the ultimate reward: Long Island Sound. Certainly if one were to nominate the Connecticut River ferry for tourists to take, it would be the double-ended *Selden* plying the glorious, high, downriver country beneath the battlements of Gillette Castle to the

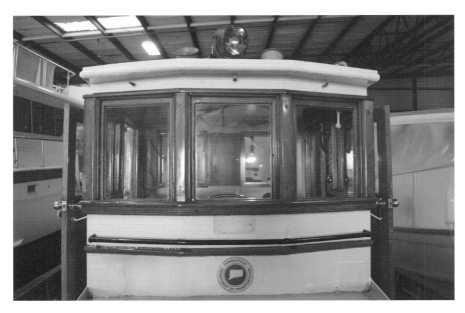

The wheelhouse of the *Cumberland*. Her brightwork is freshly varnished in anticipation of the 2017 season, which was frequently interrupted by unusually high water all summer long. *Photo by Jennah E. Smith.*

Deckhands preparing the *Cumberland* for her "splash" into the river to begin the 2017 season. Joe D'Amico is on the left and Sal Spatola is on the right. They both grew up in Sicily and immigrated to the United States as teenagers. Sal was a Boston police officer. Their paths crossed again when they became crewmen on the ferry. *Photo by Jennah E. Smith.*

charming village of Chester. But the oldest continuously operating ferry in the nation is this one, and though she can only take a third of the vehicles per run, by day's end, according to the Department of Transportation, she has outcarried the *Selden* four to one. The popularity would not seem to be over scenery but more likely the east–west commuter traffic just below Hartford. For me, the attraction is twofold: this is the first ferryboat, indeed the first commercial boat I was ever on, and second, she must perform a risky maneuver known as the "round-up."

We arrived in mid-morning with a three-man crew in what is now known as Shipyard Park, a manicured ground sloping to the river that had been the congested site of the former Hale and Hollister Yard, which in the nineteenth century produced not merely river craft but blue-water vessels.

Now at the bottom of the parking lot were two old friends. The last I'd seen of the vessels had been over a month earlier some thirty miles downriver in Essex. There I'd had the chilly pleasure of witnessing *Cumberland* towed out of her cavernous winter shed and backed onto a travel lift. Wheeled in swaying slings a few hundred feet to the edge of the macadam, she was gently lowered over the bulkhead and into the icy river

water yet uncomfortably high with freshets. There she joined her big black car barge, *Hollister III*.

The odd byproduct of the launching had been that with each move toward her summer environment, her twenty-eight feet looked smaller and smaller as her background waxed larger and larger. Now, set bow on between the slipway pilings with the wooded shore of the far bank across the river behind her, the red-and-black tug had shrunk even more alarmingly. Her woven rope bow fender, once a jaunty double moustache bow pudding, looked more comical than industrial. Yet decked out in her colorful, wind-extended flags, she might have been the pride of a tiny but no less imperial navy. Indeed, despite her size, she was queen of the river, for none of the summer's local yachts that I had seen last fall had yet to brave the spring's high water. Snugged up next to her and lending purpose if not beauty was the low-slung *Hollister III*.

Seeing the little tug again, I fell in love with her all over. In this age of expensively ugly workboats, I wondered how she had somehow snuck through. I later discovered in *The Encyclopedia of Yacht Designers* and W.M.P. Dunne's *Thomas F. McManus and the American Fishing Schooners* some of the

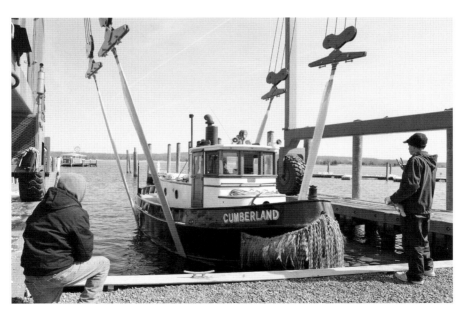

Captain Tom Darcy and Essex Boat Works leadman Frederick Schavoir guide the *Cumberland* into the water, her natural element. *Photo by Jennah E. Smith.*

The *Cumberland* was built in 1955 by Blount Marine as a rush job to ensure that the oldest continuously operated ferry service wouldn't miss a season. The boat it replaced had been condemned by the Coast Guard. *Photo by Jennah E. Smith.*

answer. *Cumberland* had been designed by the great Walter McInnis (1893–1985), whose career spanned most of the twentieth century and whose background seemed itself designed to provide him with the greatest possible opportunity to excel in the creation of exemplary, serviceable vessels. His Scottish family landed in Prince Edward Island before moving to Bangor and thence settling in Boston, where Walter's father was, in the phrase of Llewellyn Howland III, "the Tiffany of home builders." At fourteen, Walter began his maritime "coaching tree," apprenticing to his South Boston neighbor, Thomas F. McManus. McManus was a Dublin Bay sailmaker who had immigrated to Boston as a fishmonger and ended up inventing the knockabout fishing schooners and designing other Banks schooners such as William F. McCoy's notorious queen of Rum Row, *Arethusa*. After a year on the New England Telephone and Telegraph survey, Walter, through McManus influence, went to work for George Lawley & Son (fl. 1874–1945) in South Boston from 1912 to 1924. Here at City Point, in addition to Lawley's designs, McInnis observed on a daily basis, as Walter Voigt's puts it, "some of the most luxurious, durable and famous yachts of the age" as Lawley had become "the yard of choice for many of the most important contemporary yacht designers."

Starting in 1924, McInnis, now on his own, generated a wide variety of plans from competitive sailing yachts to Down East sardine carriers and rumrunners and even Coast Guard patrol boats to chase the rumrunners. Edsel Ford's commuter, later owned by JFK, was a McInnis. John Levitt, famous coaster schooner skipper, author and artist, worked for McInnis. Gunboats in the Korean War were another McInnis product. In *The Encyclopedia of Yacht Designers*, Daniel B. MacNaughton and Llewellyn Howland III capture the essence of a McInnis yacht as "timeless…[but] not nostalgic…handsome" vessels that, whether commercial or yacht, "usually retained at least a trace of workboat character." As for *Cumberland* herself

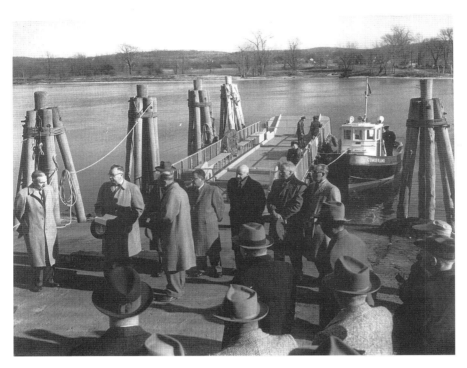

Local and state dignitaries gathered at the ferry slip in December 1955 to see the brand-new *Cumberland* make her only trip of the year to keep the Rocky Hill–Glastonbury ferry streak alive. *Courtesy of Rocky Hill Historical Society.*

as an example of the influence of Walter McInnis, she was, in Llewellyn Howland's phrase, "a type of boat that might go unnoticed by a casual visitor but is simply riveting to the experienced eye."

Emerging now from *Cumberland*'s wheelhouse, and making the tug look even smaller, was a man in early middle age, decked out in a white office shirt, pressed khakis, ball cap and glasses. When he stepped off the barge and extended his hand, I could see that he, like his tug, sported a moustache. But for the round logo with the anchor on his shirt, he might have just come from going over the accounting books. He introduced himself as Captain Blaise Clemente. He announced that our friend Tom Darcy, who had guided us through the Essex phase, had the day off. However, anything Captain Blaise could do to help the film crew he would be more than glad to do. To fix his last name, I mentioned the ballplayer, and he nodded. For the first name, I brought up the French polymath. This time, he broke into a broad grin: "Absolutely!"

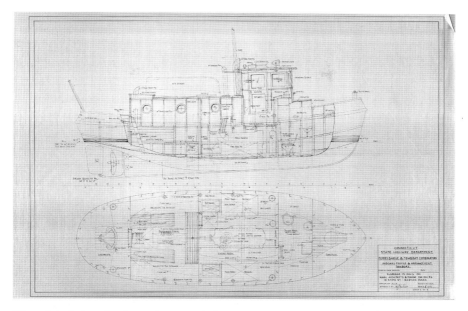

The original plans for the towboat *Cumberland. Courtesy of Captain Tom Darcy.*

"And I see you are using his principle," I pointed to the deckhand who was effortlessly spinning a wheel that noiselessly, through a system of red pipes, was lowering what had been the heavy steel bow bulwark into a horizontal posture. There was a reassuring clunk, and there in place was our vehicle boarding ramp. "Yes, Blaise Pascal, his hydraulic principle," he said. "And no doubt several other of his ideas here and there."

As the camera crew set up their gear aboard the barge, the captain and I went immediately into the topic of the day, the late season due to high water. He said, "With fog, we just look out on the water and if we can't see the other side, we don't run. With high water, it gets more complicated."

In January at Hartford, ten miles up, he explained, the river had peaked at seventeen feet above mean low water, which was within a foot of its usual range, but it had stayed high throughout the winter and early spring.

"This is only our second day," he said. "Downstream, *Selden* has been running for three weeks." I asked him how this discrepancy had come about in the same river only some two dozen miles apart. He replied, "22.8 miles, actually. It's the meadows over there." He pointed across to Glastonbury. "Although it is, as you say, the same water, a freshet that's say twenty-two feet at Hartford is down to fifteen at Middletown and goes down rapidly from

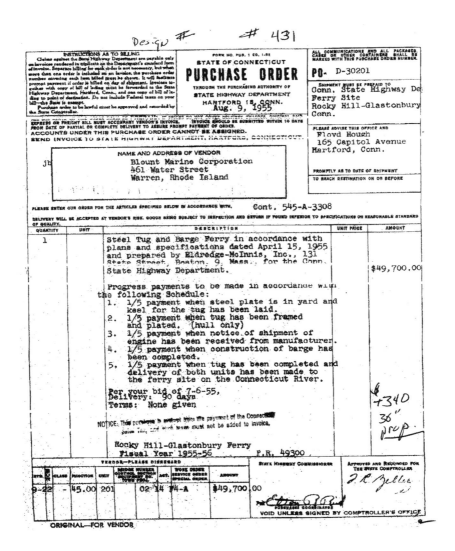

The purchase order for the *Cumberland*. She cost $50,000. She would cost millions in the twenty-first century. *Courtesy Captain Larry Stokes.*

there until what you see as variation is pretty much all tidal. In high water, we can't use the ramp over there, and that's when the Coast Guard steps in. The Coast Guard doesn't like it when the boat hits the road."

It struck me as somewhat amusing that my old outfit, one that had always tried to advertise itself as being as blue-water as possible, should get itself caught in a situation where it was called in to judge such a lubberly issue as

a boat hitting a road in a meadow. "Oh, yes," he said. "They're quite serious about it, and sometimes the water is a lot worse. We had so much one year over on this side that even to get to the tug we had to use a canoe."

Two months later, the Rocky Hill–Glastonbury ferry had to shut down again for high water.

The dampness of the Glastonbury Great Meadow put me in mind of stories my father had told me about the days before the dikes up in Hartford when the east bank from Windsor on down would flood. It was in such days that he had commenced his boating life by putt-putting about among the ridgepoles of the inundated tobacco barns in his first boat, a beat-up cabin cruiser he called *Sea Bat.* "The tobacco growers weren't that anxious to have those dikes go up," my father told me. "They profited from the annual flooding, which brought rich soil, and the barns were designed to take the high water. Because of the wide plain, the river didn't rage as it later did when dikes squeezed the flow."

Departure and arrival are the bookend ceremonies of life. Most river ferries concentrate the celebration so that it takes but a disc jockey's playtime on a Top 40 hit. Here the operators even throw in a maneuver they call the "round-up," and spectacular though it may well be, like everything in the enterprise, its purpose is entirely functional. The round-up has barely time to separate the departure from the arrival. An existential drama that must be played out each crossing, the show is a breathtaking spectacle, or ought to be if one realizes what is going on. Most of the time, however, it is received by passengers as a bit of what seems fussy business among the employees that goes on off to the side. The passengers themselves seem more concerned with looking straight ahead at the opposite shore, or if that is an event that is not happening fast enough, they are mesmerized by their handheld devices. And naturally enough, the crew plays down the drama to avoid alarming the clientele. One man I observed the previous year had been scrunched down in his hatchback smoking a cigarette while he locked both hands on the steering wheel as if his corrections would somehow be translated over to the rudder of the tug. Indeed, I myself that year only caught the show out of the corner of my eye and was alarmed at what I at first thought was some cavalier cowboy antics on the part of the crew.

The round-up takes less than a minute and is accomplished by captain and deckhand working perfectly in a *pas de deux,* with the deckhand never breaking into more than a quick step or the captain ever raising his voice, or most of the time seeming even to speak at all. It's one of those maneuvers that, if timed right, calls for neither muscle nor dialogue. Should, however,

The towboat *Cumberland* swinging the barge *Hollister III*, rounding up to tow her "on the hip." *Photo by Jennah E. Smith.*

the deckhand fail to thread his way through the passengers milling about on the barge deck or stumble or be too long at watching the river wildlife or the pretty girl in the top-down convertible, the dance of vectors can get quickly out of hand, and the whole rig goes literally south.

Then suddenly we do not have a ferry but two separate entities. Which is the true ferryboat? Which is merely the ancillary device? Which is the knight? Which is the squire? It's almost as if the two vessels now sense the mere fiction that they are really one and then no amount of diesel power can recover the unity until the rebelling rig has gone down the great drainage beyond the point of either dignity or safety.

The round-up is indeed a dangerous beauty only justified by its necessity. The tug cannot simply reverse all the way across the river because a single screw will begin to walk the stern sideways. Furthermore, the tug needs its maximum all-ahead thrust to buck the current. If the tug turns around while yet lashed fore and aft to the barge, it finds not only another set of seamanship difficulties but now has created a whole new problem. It has placed the vehicles backward. Now the drivers, with their widely varied skills, will have to back off the barge onto the shore, a time-consuming and dicey procedure. (Downriver, the newer double-ended *Selden* simplifies

the problem by having an engine on each end. There is a set of duplicate controls so that the skipper merely strolls around to the other side of the console and faces the other way.)

Ordinarily, the two vessels are united by three lines. During the round-up, the two lines on each end are cast off and the tug is allowed to back off away from the barge, which makes it look like it is abandoning the tow. A length or so of water may even open up between the two vessels, and you have to look hard to see the one line that you hope is yet connecting them. It is a procedure routinely enough practiced around basins and docks in big seaports, but out here in the fast-moving stream, it is the equivalent of an aerial act with the two performers falling sideways downriver rather than vertically through air.

And indeed, it is a kind of high-wire rodeo, with the crew casting off and retrieving the lines as both vessels try to indulge the hydrodynamic idiosyncrasies of their very different hulls. To ensure that the bow line can be recovered in a timely fashion, the deckhand needs to find that piece of loose rope the instant that the tug runs back alongside. The state could, of course, hire another deckhand whose sole job would be to stand there holding the rope, but instead somebody invented a gadget to do just that, an iron fork sticking up chest high hard by the bit on the tug's deck below where the line needs to be fastened. The captain, meanwhile, has been busy in the wheelhouse letting the two hulls separate just enough so that he can get his vessel at right angles to the barge. Moving back into close quarters, he places his doubled-moustached bow against the barge for a fulcrum. Now he can apply sufficient torsion to pivot on his bow so that his stern gets around to align itself back up against the barge on the hip facing the other way. With bow line and stern line reset, the captain puts his engine in ahead and throttles up to proceed to the far shore.

If you watch enough crossings, you'll see that some of the round-ups start right out of the gate as soon as the two vessels clear the slipway and are concluded almost before you know they were taking place. Other round-ups don't seem to get going until a quarter the distance across, and in some of these belated evolutions, the vessels even seem for a few moments to have entirely parted ways. I think this variation is less a matter of the crew's different level of competency than the almost infinite variables in the hydrodynamics of the river. If you have ever stood on a small bridge over a trout stream and allowed yourself to become fascinated by the reticulations below for even five minutes, you will see a constant rewriting of the currents as they resist repetition in myriad variations. In a tidal river such as the

Connecticut, the possibilities are even more complex because different densities in salinity can cause currents to sink under or ride over one another and produce the kind of disruptive boils that can jolt off course even a heavy vessel steered by an experienced hand on the helm. Some of these currents seem to run, at least for a moment, vertically—that is, pulling whatever is in its stream down to the bottom. I had a student who was a state police diver who related some grim adventures trying to recover bodies in these vertical currents at Glastonbury near the ferry.

Two weeks after our visit on the river, a young man near the Hadlyme ferry jumped into the river to aid a struggling friend and as of this writing has not been seen.

The deckhand completed his round-up by reaching out over the barge rail and plucking the stern line out of the fork as *Cumberland* re-presented herself alongside. Line in his fingers, he stretched down over the safety rail at the edge of the barge to make the rope fast to the big cleat on the deck of *Hollister III*, "snicking her down," as Captain Tom Darcy calls it. *Cumberland* was now turned about, secured on the hip and merrily headed for Glastonbury.

With the round-up completed, I could concentrate on appreciating the method by which we were to make most of our remaining distance, that of the alongside tow or what is more vividly known as "towing on the hip." In his definitive *Tugboats of New York*, veteran New York tugboat captain and scholar George Matteson favors the theory that assigns the origin of the term to the way a mother carries her baby on her hip, and indeed, the crew here had just made up the tow such that the tug had snuggled her charge up to her widest beam, which is about a third of the way back from her bow. This position left the tug's stern sticking out aft, now clear of the barge so that she should be able to maneuver without her propeller creating any wash-bounce turbulence off the barge.

The trick now was to get all three lines tight. On New York Harbor tugs, there is usually a great power winch on the fantail to get the stern in, but *Cumberland* does not even have a towing bitt on her fantail, let alone a power winch. The snugging up has to be accomplished entirely by the captain turning his bow into the barge and the deckhand taking up the slack so gained. With the three lines tight, we once again had in effect a single hydrodynamic unit made up out of the two separate entities. As a byproduct of all this effort, we created a whole new marine entity, one that is a much shorter mass than if we were towing in line, but a much wider one. To maintain our course in what is now, in effect, a different vessel, we needed to create the need for a new vector. To do this, the captain kept the

tug's bow angled across the imaginary center line of this new vessel. The moustache was now pointed at the front corner of the barge. Seen from the shore, the whole rig looked like those big horses you see in parades that seem to be angled for the sidelines but somehow keep in line. Old ferry captains call this motion "crabbing."

There was now a chance to examine the line used to "snick" down the tow. It was a short piece of intricately braided rope worked into a pattern that made it flat as a belt in a summer camp craft project. Such a contrivance was obviously the product of a few hours' work and not a little ingenuity. Later, in the context of a discussion on tradition and the individual talent in ferryboat culture, I asked Captain Tom about it. He said the braiding had been Senior Captain Larry Stokes's idea and his skill. "It was just something he decided to do because it looked good, seemed to handle better and stood out from the other lines if you were getting a little behind in the evolution and found yourself thrashing around among otherwise similar ropes."

By now the deckhand had walked to the far, upriver side of the barge, and stepping over a shin-high curb, he had sought out a place to sit down. And there it was: a bench that ran one end of the barge to the other, with its back up against the outer bulwarks, and there he found his lunch bag waiting for

The "moustache" of the *Cumberland* is made of pieces of rope and protects the two boats and barge during the "round-up." *Photo by Jennah E. Smith.*

him. I began to realize that there was a not a single object on the ferry that was not at some time or other in the voyage going to be taken up for use.

I was, however, disappointed to realize that somehow I'd missed witnessing that moment in ferryboat folklore and mythology so fraught with drama: the collecting of the toll. Indeed, in most of these stories, the climax centers on this interchange. The economy of the ferryboat seems to be the principal medium by which the culture works out the theme of paying the price one owes for having lived. In the classics, it is a seriocomic bit, one of the oldest of shticks featuring the ever surly ferryman Charon, cursing his customers as he ferries them across the river to the underworld. The toll in olden days was called the *nauton* or *viaticum*, that is, sustenance for nautical passage. In the classic Greek, the coin was an *obol*, and so by extension *Charon's obol* became the "dues" you had to pay to have your body be properly disposed of. To facilitate the bargain in funeral practice, the corpse would have the coin placed in its mouth. In folk tales, we have stories such as the fox and the alligator, wherein the overly confident fox insults his ferryman (who is also the ferryboat) before the crossing is complete. The result is that the ferryman collects his dinner without the need for an intermediary monetary transaction. In straight history, financial transactions on the Connecticut River were also often acrimonious, being the subject of negotiation well into the nineteenth century. Now the argument is removed from the river itself to be played out periodically on the floor of the state legislature.

Innocent of all this tradition, our deckhand was now evidently free to rummage in his white paper bag, its upper crimping fluttering in the breeze but the bag in no danger yet of taking off overboard. I didn't want to interfere with his meal, but I sensed that this was going to be the most inert moment he would have before we closed with the far shore and a whole new set of quick imperatives would present themselves.

"Joe D'Amico," he said, sticking out a hand. "Means Joe, the friend." Like the captain, he was wearing the loose white polo shirt that had the company logo on it but wore blue jeans instead of khakis. His thick, black, curly hair was of moderate length, his moustache well trimmed. Bouncing about in tennis shoes, he looked in great shape and might have been getting set to play handball. He said he lived in Middletown just downriver on the west bank and was a Department of Transportation employee who worked the winters on the snowplow crew. It was there, two years ago, he'd gotten wind of this job. "Somebody said it was a good job, and it is a good job: same wages, same pension, same everything." He took a bite out of his sandwich.

It's a job where you're out here on the river, and that's not too bad. Except in a month or so in the middle of the day it gets to be too much sun. There's no way for you to get out from under it out here the way the boat's got to be rigged and what you got to do to make everything come out right. It can get to be too much. Wear a hat, but I don't like to wear hats. Hard to get breath.

I wasn't sure if he was saying that wearing hats made it hard to breathe or the midsummer circumambient air itself was difficult to convert to respiratory purposes. On this morning, it was merely pleasantly warm, one of the first days of the year that there was no edge to the wind and it was a clean wind. We were just a few bends down, however, from Hartford—or "Hot-ford," as my father, who used to have to work construction there, called it. He also liked to point out that it was on the same latitude as Rome. I can remember coming up from the shore to Glastonbury, rising in the slowing car to the brow of Apple Hill and pausing, looking down into the river valley and seeing it choked in a purple kind of heat haze. "Looks like a goddamn fever port," he would say. And cranking up the air conditioning (when we finally had it), down into the miasma we would plunge. It was here I now thought, at the very bottom of that pile of air, that the unshaded Joe D'Amico would, in a few weeks, have to perform his riparian chorography. "Perhaps you can employ memories of those nights on the snowplow," I suggested. I had images of gentle flakes filtering a black sky.

"You dream on this job," he said. "The boat runs away and you are unemployed."

When I looked away from Joe's employment, I saw that we were not heading across the river so much as down it, following the Rocky Hill bank only about three lengths out so we seemed to be almost intruding on the front yards of some cabins on the bluff. One of the structures was cantilevered out from the bank, whether as part of the original design or as a desperate measure to save the building was unclear. There were trees behind the houses, but looming up above was a concrete tower, which lent an industrial air to the otherwise summer camp aspect of the riverside homes. "The tower was to make the new road," said Joe. "Used now for something else." I was to find out later what he had meant.

Just as I was about reconciled to going to Middletown, Captain Clemente spun the helm to port, and the whole rig slewed left into a hairpin turn. "Old jetty," said Joe. "Underwater."

When I looked across the river to where he was pointing, I didn't even see a boil. Nor did I see a buoy marking the end of the alleged impediment. Here, one would think, was a significant menace to navigation—something that could rip the bottom out of any vessel and sink it immediately to leave the passengers to struggle in turbulent Vermont meltwater. And one that was man-made to boot, something contrived and executed over the years with the sole purpose, no doubt, being to create a refuge from the sweep of the river.

I stopped looking at the water itself and scanned the bank for a range. I didn't see anything formal or even just something handy and more or less permanent, something that Captain Clemente might be using. Later, I put together something Captain Tom Darcy had told me earlier, that the homely concrete tower that had run down property values had been somewhat redeemed for captains, who had now adapted it as the back range to set their course clear of the jetty. I asked Joe if it would do to try to mark the end of the hazard with a buoy. He just laughed and made a wipe-out signal with the back of his hand, and I recalled there were few attempts anywhere above Middletown to plant aids to navigation in the river itself. Piloting was done by ranges on the shore: a short one in front of a tall one. Then when you lined them up, you would have an imaginary string drawn tight between them and a similar set on the opposite bank behind you. Get off that string and you were on your own.

"Do you ever actually get to see that jetty?" I asked. "Say August, low water?" "Summertime, low water." He sketched in the air where the bottom would then come up out of the depths.

By making his correction while yet so far from the problem, the captain had made me appreciate how much anticipation was involved in controlling this ponderous rig of tug and vehicle-bearing barge. We had now maybe yet gained only a quarter of our way across.

Tom Darcy had a story about the dangers of the submerged jetty that formed what he called the "Round-up Harbor" on the Glastonbury side. We were down in the Essex Boast Works in March. He was in the shop taking a break from painting *Cumberland* out in the unheated shed. In addition to various tools scattered about on the bench and hung on the walls, in lieu of the obligatory boatyard shop calendar girl there was a pin-up painting of *Cumberland* done in a kid's book style by one of the yard workers, Frederick Schavoir. Tom was banging his big gauntleted gloves together and stomping his feet to get warm. His wire rim glasses were just getting clear from the changes in temperature, and he shucked his camouflage watch cap back

A pair of ferry service coveralls await another day of engine maintenance, chipping and painting. *Photo by Jennah E. Smith.*

a bit off the top and sides of his face, a move that seemed to allow more room for his bristly pepper-and-salt beard. Grabbing the big brass tab on the zipper of his blue hooded sweatshirt, he gave it a measured pull to reveal another hooded sweatshirt, this one brown, over a blue jersey. It was clear that he was taking care to budget his gear precisely to the climate so that he'd have something to add when he went back out into the cold.

He'd been employed on the river about twenty years running each of the ferryboats after a stint in the navy as a radioman. Before that, he'd grown up a river rat in the town of Deep River just above Essex, the population back then defined by the descendants of quarry workers from across the Connecticut on Selden Neck. "It's called Deep River," he wanted me to know, "because it has its own river running in from the west and it gets deep right there where the town is, and *that* is the Deep River. It's not because the Connecticut is particularly deep there."

"I hate to ask you this question," I said, "because I know it's the kind of question that people ask who will never be satisfied with your answer…"

Connecticut maritime artist Frederick Schavoir's painting of the towboat *Cumberland* out of the water at Essex Boat Works. *Photo by Jennah E. Smith.*

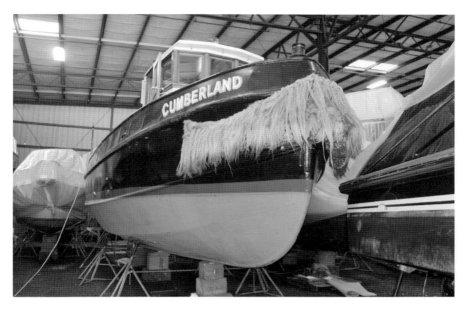

The towboat *Cumberland* in her winter home in a shed at Essex Boat Works. Note her freshly painted hull and waterline. *Photo by Jennah E. Smith.*

"You mean: do I ever get bored with running back and forth between the same two places?" I laughed. "The answer is, of course, no. Because it's not ever the same twice."

"So much for all those philosophic paradoxes."

"If you have actually had the job, you know that in terms of what you yourself have to do, the precise way you have to adjust is constantly shifting."

We began talking about the various hazards he'd be facing upriver on the Rocky Hill–Glastonbury crossing.

It isn't the jetty itself so much as the way its configuration causes the currents to transport and redeposit river sediment. Every spring, as soon as the water goes down to normal, the river has to be checked to see what the freshets have moved where. It's not only the water from upstream but the temporary ice damming here and there that can affect where the sediment ends up. In the days of the heavy barge traffic carrying fuel oil—most recently coal—up to Hartford, the army corps of engineers had the mission to dredge the usual suspects, but now that the barge traffic is given over to the truckers on the highway, it gets harder each year for the corps to justify that expense. And it's not only just in the spring freshets that stuff gets

moved around, but all season except maybe July and September you can get quick hits from up north that load up the stream.

Now we have three feet of water under the keel across our sand shoal at mean low water. The towboat, as you just saw out there in the shed, draws five and the barge less than three. Back in 2004, we had zero point zero under the keel. We made our own channel by running full speed and dropping her out of gear to protect the propeller and glide across the bar. By June, we had our safe channel.

As a result, one day what was supposed to be at least ten feet up there in the Round-up Harbor was only three feet under Cumberland's *keel. Now when you're that close to the bottom and you put the boots to her, you bring the stern down even closer into a cavitation situation and you get caught by a kind of ground effect, as you'd call it if you were flying real low. The net result of all this is you tend to lose steerage way, even if you don't ever tag bottom. And the eddy currents that the jetty creates is a force to be reckoned with at all times. It is inconsistent and constant. Right, this makes no sense. That is what makes it so much fun!*

Now about the range to make all this happen.

He pulled off his gloves and wiggled his fingers, as if to assure himself that he yet had the manual dexterity to continue the narrative.

That range was indeed handed down from captain to captain. Here it is: the outermost western dolphin [cluster of pilings] *in South Glastonbury and the cement silo in Rocky Hill. This is more or less because it is not a channel used by anyone but us; it has never been on any chart. If you are not on it, you find yourself in the mud in our little Round-up Harbor or beached on the sand shoal. We like to call it the "pucker factor."…Has it caused the faint of heart to wish they had another at-bat? You betcha.*

On the day I'm talking about, there was a rookie skipper on. It's the mid-morning weekday commute, and none of the customers are in a mood for a show. Our new skipper's just made his round-up, so he gets to letting his attention wander a bit at just the wrong time, and the old ground effect grabs him, and next thing he knows he's got the barge with three cars and their drivers up on the mud. Now what he should do here is scrub the round-up—that is, take it apart and go back to where you were just before you put the barge onto the mud. Drop into reverse full throttle and your barge will spin down and regain the range, and now you go full throttle and get out of there, resuming normal throttle, of course. With the tug turned back around,

The rudder and propeller (often referred to as "the wheel") of the towboat *Cumberland*. *Photo by Jennah E. Smith.*

you can now use her full power to ease your barge off the mud. But to have done that goes against the momentum of what you just got accomplished, so being a young man, you apply even more power and turn your helm in the wrong direction. Now you really got the barge and its three cars and customers fast aground.

At this point, the rookie does do the smart thing and calls Senior Captain [Larry] *Stokes, who, fortunately, lives nearby, and what the hell, he's run tows in the Tierra del Fuego. He's on his day off but rows out in a dinghy and makes a few soundings with a lead line, adjusts the lines, gives a few hand signals....*Cumberland *is freed up to haul her barge off the mud.*

All seems set to end well, except that one of the passengers writes it up as an op-ed piece in the Sunday Hartford paper. All done in a, you know, colorful way, no harm done, just another fun day out on the river, like running aground is all part of the show and Captain Larry Stokes emerges a shining hero, which is fine, but, hey, ol' Cumberland*'s not supposed to ever run aground in the first place.*

Well, the Coast Guard officer, who had just given the annual safety inspection, reads this with his morning coffee, and the proverbial hits the fan because this little side outing had never been reported to him, and here he's reading about it as Sunday morning entertainment!

Captain Tom stood at the window. The river began at the end of the pier. "I was up in New Hampshire last weekend. Had a hell of a good time, but I kept thinking: here the snow was high as my knees. 'All this is going to have to go by the shop window down in Essex before we can move the boat upstream.'"

Now, back up on the crossing, according to the ensign crackling from the tug's signal mast, the spring wind was blowing directly up the river. I guessed at about twelve knots. Though this direction put the breeze against the down current, there was no appreciable sea. The air was tentatively balmy—just a taste pungent, with the slightly sour smell of river water, the faint attar of upriver urbs.

Coming from the saltwater coast, I am often taken aback by the smell of so-called fresh water, which strikes me as somehow thin yet not without a suggestive content. While occasionally annoyed on the coast by the well-publicized "spills," I'm otherwise not usually concerned with what is *in* the water. Rivers, on the other hand, seem to exist on two separate levels of perception in the public mind, interpretations that seem unlikely to ever merge. There is the "Mighty Mississippi" or "Old Muddy"; the "Lordly Hudson" or "PCB Alley"; the "Great Tidal River" or the "Open Sewer of New England." That the Connecticut has been significantly "cleaned up" since the 1960s is to be celebrated. When I think how I used to swim out to my old sloop off Portland in the 1960s, I wonder how I survived. What we had on this day at the ferry crossing, at least what the eye could discern, was only the reflected fleece of the clouds and the occasion outcast of upstream woodlands. Even these were not as frequent or large as what we had seen earlier at Chester/Hadlyme, when the flotsam was easy mistaken for low-slung, riderless war canoes.

Out in mid-river, there was a moment to think about ferryboat history, which always begins with the primitive navigation on the river, largely hypothetical, condescending, half-jokey yarns about early man in his crude handwrought canoes that are one step up from a log. However, some accidental findings of small craft that had been buried, stashed at the edge of the river, do suggest that there was a sense not just of boat building but a concept of ferrying. The stashing of the boat seems to suggest the modern idea of a franchise system whereby privileged ferrymen were permitted to select a location that they wished to maintain as a sustained venue against the depredations of casual competitors.

Better documented is the voyage of the first "settler," Dutchman Adriaen Block (1567–1627), who on his fourth visit to New Netherland cobbled

together in New Amsterdam the forty-four-and-a-half-foot, sixteen-ton *Onrust* (Restless) out of the fire-damaged carcass of his transatlantic *Tyger*. In the spring of 1614, he and his crew managed to persuade her through a bad patch under what is now the Triborough Bridge, which, in honor of the effort, he named Helle-Gadt (Hell Gate).

Once free of this major hazard, he cruised on down the Connecticut coast to Saybrook, where he commenced to work her in over the unmarked treacheries of Long Sand Shoal and up into what the natives called the "Long Tidal River." He must have taken advantage of what Connecticut River historian Wick Griswold thinks was a combination of the flooding current and maybe some strong back eddies on the ebb, along with prevailing southwesterlies. In any case, he exploited the available technologies of poling, rowing, sailing, kedging and hauling from the banks. Most of all, calling on what must have been great stores of patience, Captain Block battled his way the 45.2 miles up the Connecticut River to just south of Hartford, what is now known, after his effort, as Dutch Point.

This Glastonbury–Rocky Hill crossing was something he had to traverse obliquely before heading into the final series of meanders. Viewing the wide, swift waters, I now concluded that it must have been on just such a day of generous southerly wind that he had managed to sail his chubby, under-rigged vessel up through here. On this reach, especially during the time of freshets, there clearly would have been no banks from which to haul and too much fast water to pole or kedge against the flow.

It was fun for a moment now to fantasize what Scott Fitzgerald ecstatically invoked as the "Dutch navigators." I mean, here they had actually been, not an abstraction but aboard their chubby *Onrust* yawing off before the sea breeze, holding onto their hats, literally, as they disappeared up around the bend, wondering what the hell would be next. However they managed, Block's vessel made it, and they set up a trading post until it was successfully challenged by the British. Here now is city that has established such dominance over the river that you can cross it in a car on three different bridges within fifteen minutes and never even need to know that you have been over a considerable body of water that is moving outbound to the sea.

Then there was the question of why, out of all the opportunities on rivers and creeks from Toad Suck, Arkansas, to the venerable (1683) Tred Avon in a corner of the Chesapeake, this particular operation should survive since 1655 as the "nation's oldest continuous crossing." What was there and, for that matter, still *is* about Rocky Hill or South Glastonbury or their

hinterlands? Here is a niche range of traffic that on the one hand justifies a ferryboat, while on the other hand does not have so much traffic that it requires a bridge, as does, say, the crossing of Route 3 at Wethersfield only two miles upriver.

Some histories give past credit to the nearby feldspar quarries, but these days, the answer one would think might rest not so much in the landing towns themselves but where this crossing lies on the long-distance east–west routes through the state. The junction of State Road 160 and 99A is in Rocky Hill. The ferry has the mission of carrying Route 160 east over the water, which, according to the Connecticut Department of Transportation, it accomplishes at the average rate of four hundred people per day during the season. Whether this number is sufficient to support the outlay is the subject of periodic review.

Where are these people going? Talk to the crew and you get the sense that there is a strong morning and evening commuter pulse (if not rush) that shuttles workers between their residences in the Rocky Hill area and the big aircraft plant at East Hartford, with some backflow of east bankers working a day shift at the State Veterans Home and Hospital. "On these occasions," said Captain Darcy, "we treat the ferry as DOT infrastructure and hustle the product on through the system. Later in the day, we get the sense that our passengers are tourists who want a bit of a show, and we put on our park guide hats, so to speak. The license plates, of course, are a help. I guess it depends upon whether you think of the ferry as an obstacle to overcome or a destination in itself."

Add to this two-part market a third demographic that partakes of a bit of both of the others, people following a diagonal drift across the state from Boston to the New York City end of Connecticut. Call them Big City Travelers Open to Mild Digression.

As if responding to a cue, our single passenger stepped forth from his dark SUV to assume a proprietorial posture, standing, arms folded, leaning against his shiny vehicle. From there, he could look downriver over the foredeck of the *Cumberland*. The tug had settled into its on-the-hip position snuggled up to the aft half of the *Hollister III*, a position that made our platform just high enough so we could see over the top of the tug. Downriver was framed through a cluster of gear atop the wheelhouse. I picked out a pair of cowl-mouth ventilators, a power megaphone, spotlight, port and starboard running lights and a chrome trumpet signal horn. Above all, flying in conformity to flag etiquette from a jaunty gaff on the signal mast, was the national ensign.

The passenger was bareheaded but for a pair of rimless glasses, and what there was of his hair was close cropped, with a full but neatly trimmed moustache making up for the smooth, round top of his head. His olive, tightly woven tweed sport jacket was buttoned up over a light blue shirt lashed home at the neck by a red and blue tie. His neatly pressed khaki pants looked a gauge heavier than would be comfortable a month from now. It was as if being so dapper, he needed no further protection from the wind over water.

He wanted to know if I had managed to purchase any shad and tossed a gesture over his shoulder. Looking back where we'd come from, I could see receding in the boat's wake a large white shack with big red letters on the side like a lightship announcing the house's specialty:

Shad Row

It sure beat the deliciously shabby signs of the 1940s when the fish was advertised along the highway on the backs of shirt cardboard.

The passenger ducked back inside his vehicle to extract a Ziploc plastic bag, which he eagerly opened to show me what I could already see from the outside: a dark, reddish knot of moist entrails. "Not only shad," he said, "but shad *roe.*" He shook the richly pungent bag under my nose.

He pointed out to me that although we were all headed to Glastonbury, I would have to move fast, as the place behind us closed early. I began to get the idea he was involved in the merchandising of this gnarly substance.

"Shad roe," he said again, and this time Joe D'Amico was right there to peer into the bag and acknowledge its riches. Did I then imagine that the captain leaned out of his wheelhouse window and gave a thumbs up? Or was that for something his deckhand had just performed?

It did seem everyone was cheering for the shad, and I was beginning to wonder if the passenger made this trip back and forth all day hawking his wares when I noticed the Massachusetts plates on his expensive car. Upon my inquiry, he admitted he lived in the Bay State. So convinced was I, however, of this man's formal connection with the shad shack that I immediately charged the presence of the out-of-state license to the fact that the man had far-flung commercial interests. When he revealed, furthermore, that he was an emeritus professor of architecture from Auburn, that only extended my sense of the remarkable range of Auburn professors. In a moment, he was explaining that he usually traveled on the river in a wood and canvas canoe, which struck me as, at best, perilous, but

before I expressed my doubts, he proved it by showing me his roof rack, which bristled with pads, straps and heavy-duty buckles, though the canoe itself was not at the moment astride.

"This is a delightfully *redeeming interlude*," he said and unfolded his arms to conduct a few measures of a river symphony I could indeed almost hear. "I tell my grandkids that we are not just crossing a waterway but going back in time. On one bank, you have a hundred years ago." He pointed toward the Glastonbury side, which for all we could see of civilization was a thousand years ago. "On the other…" He merely cocked his head toward Rocky Hill, which I had found a combination of the 1930s somewhat precariously balanced with contemporary intrusions.

"The unanswered question about ourselves," he sighed. "Why do we let the past slide away so easily?"

He then introduced himself as Jack Williams and admitted to having just published a book about the interstate's effect on the American small town.

"Interstate versus small town: a disaster I would imagine," I responded.

He laughed. "Yes, that's pretty much it in three hundred plus pages."

The more we talked, the more it became apparent that the professor's frequent visits to the crossing with his canoe and his grandchildren had served to not only form but constantly renew his sense of the moral center of his book's thesis, a feeling confirmed when I later read his marvelous book, *Easy On, Easy Off: The Urban Pathology of America's Small Towns*, wherein he is "[r]etracing the past to pick up the threads of forgotten narratives of the American open road." For an "open road," what could be more open than a ferryboat ride? As for his intense devotion to shad roe, I now understood this as less a gourmet's enthusiasm than a way he had of eating the essence of the river.

It occurred to me that one need not be a professional connoisseur of alternate travel to enjoy the interlude that is a ferryboat trip. Any ordinary drummer flogging auto parts or canned ham may, like the professor, step forth from the steel and plastic trap and, for the duration of a disc jockey's three-minute record, permit the river wind to blow through his soul.

As for the shad, no other fish more evokes what is in the old culture of the Connecticut River than the shad, and the ferryboat and professor brought it all back to me. I had met the fish in great numbers one May upriver at the huge Holyoke dam just north of Springfield. I'd had a job helping procure live specimens for an experiment in the evolution of a brain enzyme from lampreys to *Homo sapiens*. The very primitive lamprey had traveled all the way from the mid-Atlantic Sargasso Sea to join the

shad at the mouth of the Connecticut in a common spawning run up the river to fresh water. The lamprey is an ancient sort of pre-eel with circular sets of triangular teeth and flapless ears. Of late, it had been taking advantage of fish conservationists, hitching a ride up shad ladders and making depredations of genocidal proportions on trout and other food fish upriver as far as the Great Lakes. The hydroelectric dam at Holyoke was the first step in the line of defense.

Spewing water from its grated floor, an outside, open freight elevator brought the shad and the lampreys up from the river to the top of the dam, where in the deafening din, three or four young men in hip boots stepped into the car and began flinging the gaping lamprey out over the rail, where they plummeted what must have been two stories back into the river. Thus edited, the shad were transferred laterally over the top of the dam and sent on their merry way. On the huge face of the dam, maybe a half dozen lamprey were still struggling upriver, sucking their way ever upward on the concrete. From a distance, they might have been so many leeches. I took one home and set it out in a jar of formaldehyde on the bureau, where it greeted me each morning in what seemed to be a slow but perpetual memento mori rictus.

Shad fossils go way back. It is a member of the herring family, delicious if boney and greasy, the later negative quality addressed traditionally by what are called "plank dinners," whereby a shad is nailed to a board and set upright by an open fire to drain spectacularly while a select group of the region's important people stand around drinking whiskey and making political contacts. The most famous I know of these is held each spring in Essex at the Dauntless Club around the corner from the Essex Boat Works. There is a plebian version run for charity at one of the local schools, the dinner music supplied by the Essex Fife & Drum Corps, the detonating field drums of which, while fueling patriotic sentiments, pretty much shut down all presystolic action.

To add to the festive moment of the shad run, the bush that bears the fish's name comes into its spring glory at the same time. In some parts of the country, the plant is known as "the service bush" because its flowering signals that the frost is out of the ground and burials can now take place.

Perhaps most interesting about the shad is that while expert fly-fishermen do claim to hook a few, the fish can only be taken in commercial numbers by net and best at night, when the fish run high in the water column but cannot see the twine. Through the years, a small lug-rigged boat was developed for this purpose and, with oar and canvas, worked the river nights with lanterns.

You still find a few of these trim little craft here and there, and the modern Concordia Sloop Boat is modeled in large part on them.

In between catching and serving the shad, there are two stages that require a patient skill approaching the artisanal: boning and smoking. A small group of women with finely tuned motor skills must bone them, the trick being to leave enough flesh on the skeleton so that it holds together to facilitate lifting out the many tiny bones as one and at the same time not waste meat.

As for eating shad, I've found the fish best smoked, and there are yet a few old-timers along the river, usually shad fishers themselves, who set up in their backyard cinder block garages with home-wrought cookers to provide for this market. The last shad smoker I did business with had an excellent product but seemed to have miscalculated somewhere along in the process and had eyes ringed red, as if suffering from a combination of peering by lantern all night at thin-meshed netting and the ocular equivalent of smoke inhalation. The community should have taken up a collection for a statue.

Out on the broad back of the river now, we had the vista up into the tail of the big bend just above Rocky Hill where the hard, high basaltic ground that gave the town its name had forced the river to lunge almost due east before it found the South Glastonbury Great Meadows, through which it cut with a vengeance to make up for lost time on its way south again. It made me realize that the true river was not the kind of static, square piece of water that presents itself at a landing but something of entirely different proportion, with a huge intention of its own. Looking up into that bend as it came cranking around out of the east, I had a prizefighter's sense of facing an enormous, roundhouse left hook. And unlike the long, straight shot downriver above the Chester Ferry, this reach was one whose power lurked just round the bend but whose ultimate source behind that could only be guessed at.

It was this roundhouse hook that made Rocky Hill such a dangerous port in times of high waters. Looking out for the kind of canoe-sized flotsam we'd seen earlier in the morning down at Chester, I spotted some low, long shapes that were somehow coming upstream from Cromwell. It was as if the east–west surface of the river were being cross-stitched to illustrate its true, if unseen, north–south dimension.

Joe was taking snapshots with his smartphone and pointing out what he saw to the professor, and in a moment, the elongations had become bumpy with articulating figures. It didn't take long for them to define themselves into rowing eights up from Wesleyan, some seven miles downstream. You could

appreciate their speed against the current only when you saw the wakes of their motorized chase boats, and the entire procession was gone in a blink up against all that current around the bend. Our film crew had swung its lens on the action but soon gave it up as out of range. "All we get is some flashing bits of water; could be fish."

We were now in the process of heading back upriver to recover the ground we had given away to get our angle on the landing, all those shad and lampreys deep beneath our keel. With or without hazards to avoid, river ferryboats tend to run a parabola rather than a straight rhumb line from bank to bank. (Stand on the battlement downriver at Hadlyme and be steadied like a woozy god by this etched parabola, how the ship's wake holds its shape, engraved into the silver surface of the ever-ebbing stream.)

It is in the parabola that the poetry of the river ferry most essentially resides. Ferries traveling from, say, New London to Orient Point or Newport to Block Island have their charm, but they are basically prosaic, straight-line operations. It is on the river where the necessity of the strong current forces the pilot to, in Polonius's words in *Hamlet*, "by indirections find direction out." Geometricians can get blindingly complex fast in discussing parabolas, and the editors of *Parabola* magazine love to deconstruct mythologies by having us accept that "the parabola represents the epitome of a quest." From the point of view of the ferryboat operator, however, the purpose of this elegant course is to ensure that in its approach to the landing, the vessel is primarily facing head-on into the current rather than meeting it sideways. In this, the boat resembles the airplane (and the bird), which also needs to avoid landing situations in crosswinds. In both cases, the opposing current serves two purposes: the first in giving you truer control over steering and the second, by resisting, helps take speed off in a mechanism that has little braking power in the fluid medium.

We had by now come to that moment in the fable where the fox traditionally feels the fatal false confidence that lures him into commenting on the ugliness of his ferryman, the alligator. Although the deckhand apparently was not a scholar, he did seem to be responding to this ancient moment in the rhythm of the crossing and was bustling about preparing dock lines. We were fast closing with what had been the mysterious, wooded far shore. Although we had by and large crossed the river, we were yet several hundred yards below what, by its pilings, would seem to be the actual landing. Captain Clemente put his helm hard to port, and we made an almost oblique turn left, heading up into sheltered water behind a modest point. Could it have been this innocent feature that had caused us to swerve downriver over

by the concrete tower and evidently had been the subject of Tom Darcy's grounding narrative?

We were to be at last rewarded by achieving the promised variety of the final edge, in this case the soft meadow of the South Glastonbury shore. Closing with the bank, we saw no other structures than the pilings, and though I spotted no vehicles, a few people had gathered at the river. They were standing very still and oddly but somehow dramatically grouped. There is something out of place and time about a group of people standing at the edge of a river, something in the loose composition of spacing and focus that makes for a unity that is yet individually arranged. At a crossing, there is the added concentration that appears no less intense among those who have no intention of making the voyage or even seem to have a personal interest in anyone arriving. These folks were standing as if posing for a spiritual engraving illustrating that favorite funeral meme about the friends of the departed serving as greeters upon the Far Shore, or maybe merely certifiers that Charon's obol had indeed been paid. I thought of my father, who had introduced me to this place, and his odd excitement that I had not then quite understood.

I looked to see if any of these people had fishing gear, but everyone seemed content to just stand there without any other entertainment than the pure arrival of the ferryboat. I recalled how down in the Caribbean on St. Lucia, it was the chief activity of much of the population to stand on one side of the local ferry crossing at Marigot Bay and monitor each trip, occasionally making the voyage themselves to the other side to switch perspective. (It was a free ferry, so economics did not enter into how often one crossed.) But that has been classic Third World stuff, and here we were on a weekday morning but twenty minutes from one of the nation's great aircraft factories and the insurance capital of the world.

Against the leisure of the people on the shore, Joe D'Amico was a contrast in industry, preparing his docking lines. In the wheelhouse, Captain Blaise was hunching and twitching his shoulders, and there were answering rumbles from deep in *Cumberland*'s belly. Great whooshings of brown water flopped and frothed out from beneath the tug's fantail, and the film crew stuck their camera as close as they dared.

As Captain Blaise, in the necessary privacy of his wheelhouse, performed his themes and variations, I thought of how we had worked so hard down in the cold at Essex to get the shot of Captain Tom beneath the hull explaining the forces at play during this very moment; how on one take he had so elegantly used his hands like birds to show the fluttering vectors of the river

current and the counter swirl of the propeller echoing off the barge. But something had gone wrong with the microphone, and now we would never get it—never have anything but this mocking vanity of brown bubbles on the surface; and I was nearly overcome by the desire to grab the camera and heave it into the river.

I was woken from this dream of violence by the harsh knocking of an automobile starter motor engaging prior to combustion. This noise, of course, was the work of the professor, who was leaving us after all. For an instant, this inevitable submission to the interstate struck me as a betrayal. But what had I expected of him? That he would give up home and family to live forever afloat, sailing from shore to shore, a martyr to a kind of compulsive lyricism, a life all interludes and no act?

But of course, not even he could leave the boat until Joe had cranked down the ramp and opened the safety gates. Bracing himself with one hand on the red hydraulic cylinder at the end of the barge, Joe leaned into cranking the big, gray wheel with the other, spinning it as if he were mixing up a batch of some great pudding. What happened was that with an oozing sort of rumble, the ramp, which had been nearly vertical in order to form the bow bulwark, now slumped down to the horizontal to make contact with

First Mate Sal Spatola closing the gate on the barge *Hollister III*. Sal loves working outdoors and interacting with the passengers. *Photo by Jennah E. Smith.*

the shore ramp. I recalled a friend who had a billet on a landing craft in the Pacific in World War II relating such moments when without hydraulics, but a mere mechanical winch, he would lower the ramp in the assault boat as the men rushed forward to their fate. Here, while in early days there may have been some unpleasant moments, now it was merely the professor carefully peering out over his hood as he bounced gently off the boat and, while the film crew tracked him, vanished up the narrow road into the long water meadows of a peaceful South Glastonbury.

Even as the camera snout was lifting, the on-loading cars were clattering aboard, a diminutive primavera parade. A few people seemed to search our faces as if we would reveal some secret of the other side. Would we, based on our great knowledge of the voyage, issue some sort of last-minute warning?

The last of the three was an open convertible. A woman was at the wheel, and she seemed radiant with anticipation of the voyage. Her hair was newly washed so that I hardly noticed the glitter was from the chromium wheelchair folded into the space behind the seat. On the bankside above, as the boat backed away, the tableau of watchers relaxed into their valediction.

CHAPTER 4

BAILEY BREAKS A CABLE

The first spring freshet of a brand-new century ran high and fast on the morning of April 6, 1901. Lawrence Bailey, an East Windsor farmer, maneuvered his two horses and wagon onto Bissell's ferry for what was usually a routine trip across the swollen river. The wind was up and it was a gray, chilly, early spring day. He and the boatman traded pleasantries and weather commonplaces as the current pushed the flat-bottomed scow across the river. The boat was attached to a cable that spanned the water from the east to the west bank. There was a sharp-ended rowboat lashed to its side and an anchor of the type called a fisherman tied to a rail. The design used the force of the current to propel the craft across the river. It was a time-honored method and an early example of sustainable energy use in a riparian setting. Bissell's ferry had operated on pretty much the same principle at the same spot on the river since the middle of the seventeenth century. It was a system that worked.

Or not. Bailey drove his team into the business district of Windsor and picked up a few items his wife had requested and a new harness for one of his horses. He then proceeded to Thrall's tobacco warehouse and loaded several crates of good Windsor broadleaf onto his trusty wagon. He made his way back to Bissell's ferry slip in the late afternoon. The river was up significantly since he'd gone ashore, and the wind was stirring some whitecaps. As he waited for the boat to return to the Windsor side, Bailey pulled the collar of his well-worn denim jacket up and pulled his floppy felt hat down over his ears. The thought of the Yankee pot roast and potatoes his wife would have

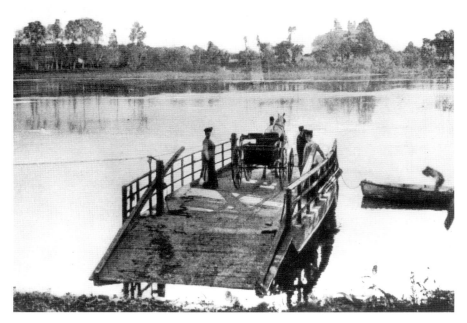

Bissell's ferry in Windsor. Note the cable that guides the scow across the river and the rowboat that saved Bailey and the ferryman. *Courtesy of the Connecticut River Museum.*

waiting by an inviting fire warmed him and made him anxious to get home and get the horses back in the barn and fed.

The boat finally returned to his side, carrying a horse and buggy and a few passengers. The boatman was reluctant to attempt another passage across the spate of water. The wind was increasing, and rain showers began to spit out of the cold mist. Bailey had no interest in spending the night in Windsor. He would have to conjure up a place to stay, and there were some chores he still needed to do. His wife might think he was carousing at a local watering hole, and he had no way to let her know the delay was out of his control. He cajoled the ferryman, perhaps wheedled a bit. They ultimately agreed that they would make the trip, but the boatman would remain on the east side and stay at Bailey's farm rather than assay to cross back in the blackening night and building wind.

They managed to get the horses and wagon on the boat, a task not easily accomplished, as the swollen river had forced the ferry to land at a less accessible angle than usual. The loading apron was even more slanted at a sharp tilt, and the platform was bouncing in the waves. The darkness made loading difficult. The horses were skittish, but the men wrestled and groaned

to get the heavily laden wagon and its two patient pullers aboard. The ferryman, once again, expressed his misgivings about the trip, but Bailey propped up his position that they proceed with a shiny silver dollar that featured the profile of Lady Liberty. This swayed the recalcitrant waterman, and the two men and two horses cast off from the Windsor shore and ventured out onto the angry, inky river.

The flood pushed the current faster than the riverman had ever seen it. Its increased force, coupled with the weight of the loaded wagon, the horses and their tack, placed more and more strain on the wire cable to which the boat was tethered as it made its way across the river. The cable had been perfectly serviceable for years, but this particular evening, the laws of entropy prevailed, and the strain and stress caused it to snap neatly in two at a point just about in the middle of the agitated river. This event left Bailey, the boatman and the horses in a bit of a fix.

The floating platform, freed of its tether, began to careen down the river at an alarming rate. It spun in the current and threatened to capsize and send its cargo and crew into a hypothermic welter of water. The ferryman located and unlashed the rarely used anchor and managed to get it over the side in hopes of slowing and stopping the boat's progress. The problem was the anchor line had been shortened when some rope was needed for a minor repair, and there wasn't a lot of scope available. The flukes bounced along the bottom and did not find any purchase in the sand and silt below. The boat's speed continued to increase. The horses, sensing something wrong, began to whinny and kick in their traces. Bailey was not a religious man, but a long-neglected prayer found its way to his lips.

Just as their situation was at its most perilous, the dangling anchor snagged on a submerged rock and the anchor line snapped straight as it took the full weight of the vessel. If a steel cable gave way under such stress, surely a hemp rope would, too. But it held! The boat spun into the current and came to an abrupt stop. The bow, or the stern, since they were essentially the same, pointed upriver, and the castaways let out a sigh of relief. Their immediate problem was solved, at least for as long as the straining anchor line would hold. It did hold, but the travails of men and beasts were far from over.

The travelers found themselves in the middle of the river. Wet, hungry, tired and inadequately clothed on an increasingly chilly night, they had no ready means of propulsion and no one to be seen on either bank who might be summoned for a rescue. Their situation, although not exactly desperate, was exceedingly uncomfortable. They did their best to calm the horses and gave them some river water scooped in an old oaken bucket. They off-loaded a couple

of crates of tobacco onto the deck and climbed up on the wagon as far out of the wind as possible and huddled together for whatever warmth two crusty old New Englanders might generate. The ferry master had some choice words for Bailey, who had put him out on the river against his better judgement. It was a long night. Horses shivered and complained. The men did, too.

The clouds moved on, and dawn broke clear but quite cold. Now being able to assess their situation, they decided that the boatman would row to Windsor in the little rowboat and return with a larger anchor, some more line and some blankets for the dangerously chilled horses. Bailey remained on the boat in the chance that a motor-powered vessel might appear to tow the rig over to East Windsor, but that was an unlikely outcome. He watched the sunrise over East Hartford, wondered what his wife must be thinking and tried to ignore the gnawing desire for pot roast.

At last, the rowboat appeared alongside. The men immediately placed blankets over the frigid horses. Best of all, from Bailey's point of view, the still disgruntled ferryman handed him a sandwich and a half pint of brandy. There was a much bigger anchor in the small boat, with a length of line, so they decided to kedge back to shore. Bailey tied one end of it to the bow/stern of the scow, and they began the slow process of kedging. The ferryman would row the anchor out in front of the ferry and drop in overboard. When it set, Bailey would put his back to it and pull the ferry up to the anchor. He would then set the smaller anchor to hold the ferry in place while the big anchor was moved toward shore and the process repeated. And repeated. And repeated.

After several hours of this backbreaking, dangerous (the river was still up, and tossing anchors from small boats can be tricky) work, the Bissell ferry finally secured on the East Windsor side of the river. Dirty, hungry, tired and out of sorts, they made their way to Bailey's farm, where his worried wife greeted their tale with some skepticism. But since they provided so much detail and obviously were the worse for wear, she accepted their story and rustled up a breakfast of eggs, rashers of bacon, potatoes and plenty of hot coffee. Bailey tended to his chores and took it easy for the rest of the day, it being the Sabbath, plus he thought he deserved some rest. The horses were glad to be back in their stalls. The tobacco went on to fetch a tidy profit, and Bailey had a tale to tell whenever he found an interested audience.

The somewhat refreshed ferryman rowed back across the river to Windsor. He made his report to the owner of the ferry operation, who groaned at the expense of a new cable and the fares that would be lost until the old one could be replaced, but he thanked his crewman for saving the vessel and bringing it and its cargo back to shore safely.

MISHAPS

Farmer Bailey was not the only river traveler to run into trouble on his trip across the Connecticut. In the course of almost four hundred years of ferrying on the Great River, humans and beasts have had their share of disasters, inconveniences and near misses. Accidents and drownings were not unheard of in the early years. The nature of ferries, with their sometimes tricky loading and unloading situations; their imperative to cross in fog, wind, tide, ice, flood, low water and darkness; on a river strewn with snags, industrial debris and other boats can create some dicey situations. Also, some of those centuries placed large animals, wagons and freight on the boats that were propelled by evolving steam technology. All of these circumstances created occasions where things could go amiss— sometimes in quite a hurry. The mishaps that happened on the Connecticut include animals, cargo and humans swept overboard; fire; groundings; sinking; mechanical failure; and passenger error.

For the most part, ferrying is a predictable, quotidian business. Each trip has a bit of uniqueness due to wind, current, weather and its complement of passengers, but excitement can crop up from a variety of causes. For example, Captain Fred Beebe, of the Chester-Hadlyme boat in the early twentieth century relates the tale of an ornery local farmer, known as "Old Man Baldwin," who, despite several entreaties from the crew, refused to chain up his team of oxen while the ferry crossed the river. The wake of a passing boat unsettled the animals, and they initiated a short backward stampede, crashed through the stern gate and splashed into the river,

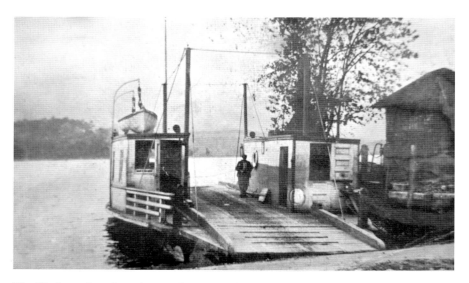

The Hadlyme ferry, late nineteenth century. *Courtesy of Captain Larry Stokes. Photo by Jennah E. Smith.*

dragging their heavy wagon overboard with them. Quick response from ferrymen and passengers disentangled the frightened animals from their harnesses and guided them safely to shore. Subsequently, the wagon was pulled out of the river, and the episode ended with a chagrined farmer and a smug captain, who reveled in "I told you so" and honed a good story to tell the lads at the local pub.

The weather can sometimes interfere with the predictability of ferrying. In the middle of the nineteenth century, a farmer, who was far more prudent than "Old Man Baldwin," drove his team of oxen and wagon loaded with hay onto Captain Solomon Belden's sail-powered ferry in East Haddam. The farmer brought along a boy to help him with the load. Captain Belden also employed a boy to assist him in guiding the ferry from shore to shore. A fierce and unexpected squall blew up when the scow was in midstream and shoved the ferry sideways down the river. Realizing that capsize was imminent, the quick-thinking wagon owner unhitched the beasts from the vehicle that burdened them. The now unencumbered animals quickly jumped overboard, still in their yokes, and swam slowly to shore, where they waited patiently for their master. The farmer and the ferryman followed their good example and each took their boy upon their back, jumped over the side and swam for shore. Freed from its topside weight, the ferry did not capsize, and the

scow and the oxcart were later retrieved downstream, near the mouth of Clark's Creek.

One animal-overboard situation that resulted in a better outcome occurred on New Year's Eve 1849, when Frederick Ray of East Haddam was crossing over to the Chester side with his trusty steed—whose name is lost in the mists of time—harnessed to his carriage. The landing on the west side was a bit tricky due to ice that was building up rapidly and a wind that was picking up. The ferryman had to back off, row hard and swing around for another go at the slip. At this point, the horse gave a bound, wrenched the bit from Mr. Ray's hand and leaped overboard, dragging the carriage with him. The frightened equine began swimming back toward the Hadlyme shore. Since the water was only a few feet deep, the horse was able to make good headway. The ferryman turned his boat around and began to chase the runaway beast across the river. But the horse, still in the water, was able to make tighter turns than the boat and evaded the attempts by its owner to control it. The beast was able to free himself from the carriage's traces and thus became even more elusive. He was finally captured after becoming wedged in the ice. The boatman and the farmer were able to get a rope around its neck and were able to tow him to the Hadlyme side. He arrived back on land quite chilled and exhausted, but the farmer was able to apply some "remedies," which restored the adventurous animal to a healthy condition. The carriage was not salvageable, and its cost was remunerated to Farmer Ray because the ferryman had allowed the horse to cross without being tethered and the chains at the end of the boat were not up.

One bizarre horse-overboard incident occurred a few years later when the proprietor of the Champion House, a large boarding facility in East Haddam, lost his horse off the ferry scow. It seems that the sail propelling the ferry was suddenly back-winded, causing it to do an unanticipated jibe, sending its boom sweeping across the deck and slapping Mr. Douglass's horse in the face. The startled steed was pushed into the water off Tylerville and did not survive the incident, despite every effort of its owner and the ferry crew to save it.

In October 1895, the world-famous actor William Gillette lost a very valuable horse. While the circumstances of the accident are not clear, Gillette was of the opinion that it was the operators of the ferry who were at fault. He filed a lawsuit against the ferry that found its way up to the Supreme Court of Connecticut. Chief Justice Baldwin, who later became governor (and for whom the Old Lyme–Old Saybrook Bridge would be named), wrote up the opinion of the court that the ferry owner was not liable for the accident. In

another case that went to the Supreme Court involving this ferry, a group of East Haddam businessmen sued the Town of Haddam to compel its selectmen to raise the approach to the ferry so that the boat might land on the west side regardless of the height of the water. The Supreme Court ruled in favor of the town, and the case spurred a movement on the part of several women in East Haddam to begin lobbying for the construction of a bridge that would solve any problems with the ferry once and for all.

In efforts to keep ferry service operating all year long, it was common for ferrymen to cut channels in the ice that would otherwise prohibit them from getting across the frozen river. On January 20, 1829, the crew of the boat running between Middletown and Chatham had cut such a channel through the icy current and was attempting to get to the east shore of the river with a heavily laden scow. It carried three horses, two wagons and a cargo of wool and general freight. As men and horses were almost midstream, a "large body of ice floated down from the upper side." It smashed into the boat, which immediately began to sink. The men escaped by jumping onto the ice, which was strong enough to support their weight. The horses were not so fortunate; still attached to the heavily laden wagons, they fell through the ice and were pulled down into the frigid flow and drowned. Both wagons and all their cargo were lost and never retrieved from the river.

As sad as it is to read of horses losing their lives in frigid waters as they faithfully went about their duties in the service of humans, it is even sadder to recall those relatively rare occasions when their owners shared their tragic end. While ferry operators usually tried to provide safe passage for their customers, the dangers inherent in crossing large moving water sometimes became palpable. The mournful demise of John Woodward is a case in point. Woodward was on top of the world on the crisp, early autumn morning of September 8, 1741. He was traveling from his family home in Lebanon, Connecticut, to New Haven, where he was to receive his degree at commencement exercises from Yale College. He was accompanied by a family friend and attempted to cross the Connecticut at Chapman's Ferry in East Haddam.

What was described as "a sudden tempest of wind arose" and overturned the boat, which was said to have been old and leaky. Three other mounted passengers attempted to swim their horses ashore. But Woodward's steed sank to the bottom of the river, dragging its rider, who was entangled in reins and stirrups, down with it. Those present surmised that the young scholar apparently sustained some type of injury that prevented him from saving himself and his horse. In any event, he did not resurface and

drowned. His body was washed several miles downstream and eventually wound up in the vicinity of Brockway's Ferry in Lyme. He was buried in a cemetery near there, and his headstone bore an inscription that he died by drowning at Chapman's Ferry. The Reverend Solomon Williams of Lebanon preached a sermon expanding on Woodward's accident to explore several biblical themes.

It is interesting to speculate as to what type of boat Woodward was using to cross the river. Conjecture has it that it was a keeled sailboat that would have capsized in an unexpected strong gust. Sail-powered ferries were common in the first half of the seventeenth century. Two- and four-wheeled carriages were uncommon at that time, although they began to appear in greater numbers. In 1760, regulations were developed concerning transport of carriages by ferry. The fact that in 1745 Chapman's Ferry required a wharf would substantiate the sailboat theory. After 1750, when carriages became the norm, scow-type boats came into popular use. These boats had aprons that could be raised or lowered and could land almost anywhere, no longer requiring that the ferry have a wharf.

Alas, there are even worse disasters to befall teams of animals, carriages and the humans who drove them. On July 7, 1868, Mr. and Mrs. G.C. Davis and their nine-year-old son were seated in their carriage aboard the South Holyoke steam ferry a few miles north of the Connecticut/Massachusetts border, enjoying an easy passage across the river on a lovely summer evening. For some unknown reason, the horses were spooked and ran off the unbarred bow end of the ferry, which proceeded to run them over, with horrifyingly fatal results. The body of the young mother was recovered, but the corpses of her beloved son and husband were never found.

During the Great Flood of 1936, a spate of truly epic proportions, Captain Daniel W. Taylor, the fellow who once guarded Geronimo while a soldier when the great Chiricahua Apache chief was a federal prisoner, was guarding his brand-new barge, which was nestled into its slip on the Glastonbury side of the river while ice-choked floodwaters raged all around it. Taylor had sent his scowman, William Baker, safely ashore with the ferry's rowboat and vowed to face the flood alone aboard his brand-new barge. At one point, the barge tore loose from its lines and went spinning into the dangerous spate. In the morning, the captain found his barge and himself in the middle of the river, attached to a mooring line, several hundred feet from shore. He was marooned there for two days and one night without food and water. His clothing soaking wet, his only shelter from the biting wind was to crawl into an overturned barrel. This

allowed him to get at least a catnap or two as he endured his ordeal and hoped that someone would rescue him.

Rescue did arrive. But it didn't come easily. Alarmed at Taylor's predicament, Henry Hale, the Rocky Hill fish dealer, famous for his Connecticut River shad, recruited his two sons and attached an outboard motor to his heavy, flat-bottomed shad boat. With the engine straining, and both young Hales pulling lustily at the oars, the boat was able to make its way against the current, and the ferry captain, in the early stages of hypothermia, was rescued. A few days later, when the river finally calmed down a bit, the ferry's towboat went out and retrieved its barge. Ferry service was restored without loss of life or property, but it had been a close thing.

Captain Ben Hawkes relates the story of the Flood of 1984, which occurred shortly after Memorial Day and lasted well over a week. Rain fell steadily and hard for several days, and according to Hawkes, the river crested at thirty-three feet. In order to save the tug and barge, an emergency trip downstream to Haddam and a safe mooring was necessitated. It was a hair-raising experience, with the crew continually dodging whole trees that were cascading down the current, while trying to remember where low-lying islands, now completely inundated, were lurking. Hawkes also recalls the afternoon that a tornado hit Windsor Locks several miles upstream. Its accompanying storm created a gust from out of nowhere in Rocky Hill that completely spun the boat in a 360-degree arc.

Ice that was washed down the river by that unprecedented current wreaked havoc not only with boats on the river but with buildings ashore as well. Cakes of ice, often more than a foot thick, smashed into pilings and docks, damaging landing areas and equipment. At one point, a huge floe of ice crashed into the shanty that the ferryman used as an office, storehouse and coffeehouse. The ice struck the shack with such force that it was ripped from the concrete blocks of its foundation and plunged into the river. The raging waters carried the forlorn hovel several miles downstream, where it came to rest against a dock in Portland. It was declared unsalvageable and chopped up for firewood. A new office was built in Rocky Hill to replace it. A sloop owned by Captain Taylor was also swept downriver by the angry waters and sank off the shore of Cromwell, a total loss.

Two years after his first incident, the redoubtable Captain Taylor was once again locked in a struggle with nature. On September 21, 1938, Connecticut was caught in the path of one of the most severe hurricanes ever reported. The storm surge and rain swell was so great that the river rose eighteen feet above flood stage. Taylor and his assistant, the aptly named

Gale Clark, did the best they could to save their towboat and barge. They tied both vessels off to a stout tree with a three-quarter-inch hawser, but the powerful storm snapped it like a piece of thread. Left to the mercy of the elements, both boats were washed more than one hundred feet inland, where they came to rest against a tree on the road to the center of Rocky Hill. That tempest also destroyed a fanciful flower garden the captain had planted on the Glastonbury side in an attempt to beautify his landing spot. He had carefully nurtured over 130 different varieties of flowers, none of which survived the flood.

In Captain Taylor's day, the ferry did not necessarily shut down in cold weather, as is the custom today. Ice was often an adversary, and the captain recalled the February day that his rig got firmly stuck in the small bergs halfway between the Rocky Hill and Glastonbury sides. He had a fish dealer and a full truck of finny merchandise aboard, and it looked like the piscatorial peddler wouldn't be making any deliveries that day. But in those days, there was a good deal of towboat, barge and tanker traffic on the river, and a tow happened by while the ferry was iced in. Taylor was able to work his way into the channel that the larger vessel had cracked through the ice and then made his way upstream to a spot where he could let down his gate and get the fish truck off the boat. The van made its way through frozen cornfield and got back on the road. (Folks east of the river enjoyed their codfish dinner without interruption that evening.)

Not all of the Connecticut River ferries' close calls occurred on the river. Take the story of the East Haddam boat *General Spencer* making its way down Long Island Sound in the fall of 1907 to a New London shipyard for some much-needed repairs. The seas were running particularly high that day, and the rivermen, not all of whom were acquainted with saltwater navigation, had some qualms about proceeding down the Sound. In fact, some of the crew protested loudly that they should head back upriver even before the boat crossed the Saybrook Bar. But Bill, the stalwart second mate, and the pilot were "dead game sports and wouldn't have it." They left Saybrook behind them at 12:35 a.m., when the high tide aided their crossing of the bar. The boat proceeded east down a tempestuous Sound on a wild, black night. But they safely arrived in New London at the Morgan Iron Works at 4:45 a.m., the crewmen breathed a sigh of relief, while the seasoned salts had an "I told you so" moment.

The advent of steam power on the river sometimes resulted in misadventures when that often troublesome and precarious means of propulsion went awry. The Connecticut River ferry event that highlighted the dangers of

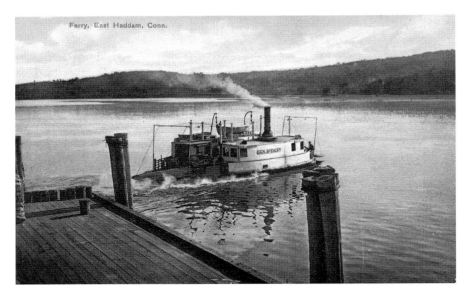

Ferry, East Haddam, Conn.

The *General Spencer* steams across the river. *Courtesy of the Connecticut River Museum.*

steam occurred on April 2, 1889. It was a beautiful spring afternoon when the ferry *Portland* left her slip on the eastern shore for a routine crossing over to Middletown. She was built in 1870 by the distinguished shipyard of H. Gildersleeve and Sons in Portland, and she was the largest ferry to ever operate on the river. Her passage that lovely vernal day proved to be anything but routine, however. Before the chuffing boat could complete the two-thirds-of-a-mile passage, disaster struck.

The ferry was in midstream under the command of Captain Cooper, a man with many years of experience guiding the boat from one shore to the other. Engineer Conroy was in charge of the noisy, cranky steam mechanism that turned the paddle wheel that pulled the boat through the water. Three teams of horses and wagons and a few passengers on deck were under the watchful eye of Collector John Patterson. Shortly after 1:00 p.m., Captain Cooper became greatly agitated when he saw smoke and flames shooting up around the smokestack. He signaled "Full speed ahead" and made for the Middletown shore. Bystanders at the dock saw the drama unfold and sounded an alarm that brought the hook and ladder truck of the Middletown Fire Department to the pier. By this time, Engineer Conroy was aware of the fire and ran to the boiler room to open the furnace door, hoping to control the flames.

Engineer Conroy started up the "donkey pump" and attached a hose to it to try to douse the fire, but the flames were out of control, and he was forced to retreat. Both the engineer and the captain were badly burned about the head and face during their effort to bring the blaze under control and save the boat. But despite the best efforts of the crew, the boat was a total loss. It was towed some distance from its slip on the Middletown side and left to burn itself out. The vessel was estimated to be worth $20,000 (over half a million in 2017 dollars) but was only insured for $12,500. The Middletown Ferry Company suffered the financial loss. It had a spare boat, but it was laid up in dry dock without an engine, so the company could not provide service between the two communities, leaving quite a few perplexed and frustrated teamsters wondering how they would get to the other side, where home or business required their presence.

The *Portland* was not the only Connecticut River ferry to meet its end in a blazing inferno. The *Colonial*, a fifty-five-foot steam ferry that was commissioned into service between Old Saybrook and Old Lyme in 1905, was embarking on the 1911 summer season replete with the usual buggies and coaches full of tourists and summer visitors, as well as increasing numbers of those newfangled, noisy contraptions known as automobiles.

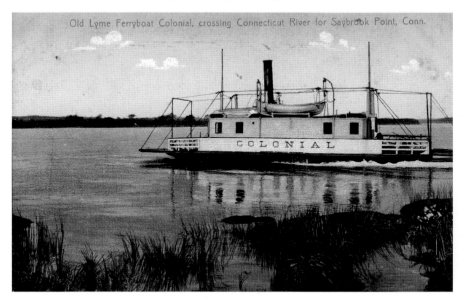

The ferryboat *Colonial*, which was struck by lightning and burned at her pier in Old Saybrook. *Courtesy of the Connecticut River Museum.*

Business was good, and the boat's steam engine was in excellent working order. The owners and crew anticipated profitable and pleasant voyages across the river all summer and well into the fall. But at 3:00 a.m. on June 11, those projections came to a fiery end. Thunder squalls blossom over Long Island Sound when cold fronts and warm fronts collide in the late spring. The storm that morning was particularly violent. While the *Colonial* sat at her dock in Old Saybrook awaiting the morning's first passengers, a bolt of electricity shot down from the sky and made a direct hit on the *Colonial*. Within minutes, she was fully ablaze. The oil she carried fueled the fire, and she was a total loss in a short period of time. Thankfully, no one was aboard at the time, so there were no injuries.

Captain Jim Grant, longtime skipper on both the Chester-Hadlyme and Rocky Hill boats, says that he has never heard of an actual fatality aboard a modern ferry on the Connecticut River. "There have been injuries to crew members and passengers, usually due to falls or slips on wet decks or ladders. But no deaths." He reports that some of the mishaps that occur every so often on both boats are due to mechanical problems. "I have been on the Rocky Hill ferry through one engine failure and several steering failures. I have had to operate the rudder by manual control. The power steering on the *Selden III* goes out every now and then, but the crew usually is able to get the boat into the dock and pull off a landing without much trouble." Captain Ben Hawkes remembers the time that new intake lines resulted in a show of one and a half inches of fuel in the tanks but no access to it. The ferry went downstream with the current for a few miles until a fisherman rescued it and towed it back.

While not mishaps, per se, the mechanical problems that Captain Grant relates can sometimes cause disruption to regularly scheduled ferry service. For example, in September 1995, service was shut down at Chester-Hadlyme when the shaft in the engine was found to be out of alignment. The ferry was off line for a week while it was towed to the Thames River Shipyard in New London. The same boat had its spring debut delayed two years later when a worn rudder post had to be replaced before the ferry could become safely operational. The tired, old part was sent off to a machine shop in Rhode Island for a $3,000 repair. The previous winter, the state had begun a $90,000 complete renovation of the *Selden III*'s electrical system, to bring it up to "1997 standards," according to the director of Port Operations for the DOT. The price of the upgrade was almost as much as the $119,000 it cost to build it in 1949.

It is not always repairs to the vessels that can keep them from performing their appointed rounds. In the spring of 2002, ferry service between

Chester and Hadlyme was delayed over six weeks because of upgrades to its landing spot. The delay was caused by "unexpected construction complexities" in the process of rebuilding the hoist towers. The project wound up costing $1.4 million. It included "rehabilitation of the ferry ramp and hoist towers, rehabilitation of the fuel tank appurtenances, replacement of electrical conduits, fixtures, and lighting, installation of decorative approach paving and construction of an elevated prefabricated storage shed." Enjoying their spiffy new digs, the crew finally got the boat going across the river in late May.

Sometimes the Department of Transportation tries to be proactive by preventing mishaps before they occur. Such an initiative was considered in the spring of 1983, when the state proposed a plan to fence off the Chester ferry dock. Local residents quickly mobilized against the idea, and a flurry of letters and phone calls peppered state legislators and administrators complaining that the proposed fence would "ruin the look of the site." The purpose of the fence was to eliminate vandalism at the ferry slip. The department's maritime officer, who is in charge of the facility, said he was open to public input: "We'll go along with it and see if we can get some fresh ideas about what to do from the public. We don't want to cause any undue concern about it. If residents would like to talk to us, we'd be more than happy to get together with them."

Although vandalism was negligible at the ferry dock, there were a couple of occasions when miscreants cut the hawsers holding the boat to the pier at night when the slip isn't manned or guarded. This was a realistic cause for concern, in that if the ferry should get loose and be pulled into the current, disaster was a real possibility. The maritime officer said, "If the ferry, which would not be lighted, should be cut loose and drift into the path of one of the barges at night, the barge would split right open, and then we'd have quite a problem. If the boat drifts off again, we're going to have to do something." A fence and gate were installed a few years later, apparently to the aesthetic approval of the local residents.

A similar incident occurred at Rocky Hill in the early 1990s. A "burglar" snuck aboard the *Cumberland* in the small hours of the morning, untied her lines and ransacked the wheelhouse looking for the key. Since the engine room was locked and the power shut off, the would-be illicit mariner was foiled in the attempt to take a joyride on a Connecticut River ferry. This incident points out one of the most inconvenient aspects of a ferry captain's job. When the alarm went off on a boat, the sleepy skipper crawled out of a warm bed at home and sped to see what was wrong with his vessel. Since

The slip on the Chester side of the river. Note the bunting denoting Memorial Day. *Photo by Jennah E. Smith.*

many of the skippers lived some distance from their slips, it was sometimes a very onerous task.

The unique ability of the ferries to get emergency vehicles quickly across the river can occasionally turn ferrymen into true heroes. For example, an unusual set of circumstances occurred on July 29, 1995, that thrust the boatmen into a life-or-death situation. On the quiet summer afternoon, some dark clouds were threatening a thunderstorm, but the ferry went about its leisurely back-and-forth business. Things became quite tense quite quickly when the staff manning the Rocky Hill Volunteer Ambulance was summoned to Ferry Park to attend to a person suffering a life-threatening medical emergency. While they were administering treatment and preparing to rush the patient to the hospital, lightning struck a large maple tree, causing it to topple across Maple Street, completely blocking the road, preventing the ambulance from leaving the park.

Captain Tom Darcy, realizing what had happened, jumped into action and immediately ordered the cars that had just boarded the barge to disembark in reverse, clearing the way for the emergency vehicle. Considering the size of the ambulance, it was a brave decision. Captain Darcy informed the police and crew chief of the EMTs that the ferry was at their service. The

captain and his first mate, Durwood Rogers, guided the large vehicle onto the barge's platform. It was a tight fit, with less than an inch to spare on either side. As an article in the *Rocky Hill Post* breathlessly exclaimed, "For the first time ever, the RHVAA [Rocky Hill Volunteer Ambulance Association] ambulance was piloted across over to the Glastonbury side of the river so that a patient could be quickly transported to the hospital. (And in case you are wondering, there was no charge for the ferry service.)"

Another situation that occurred at the Rocky Hill ferry slip did not have such a happy ending, although the captain and crew, once again, comported themselves in a heroic manner. On the last day of June 1985, it was pretty much business as usual at the ferry. That is, until a car began to careen around the parking lot adjacent to the ferry lane at speeds over forty miles per hour. The errant automobile was operated by a thirty-nine-year-old woman who was suffering extreme mental health problems. Her thirteen-year-old daughter was a passenger in the car. She must have been terrified at what was to take place at the usually placid ferry landing. Her highly agitated mother aimed her vehicle toward the ferry ramp and drove into the water at a speed estimated at fifty miles per hour. The car's momentum carried it some distance from shore, and it quickly began to fill with water and sink. All of this occurred in full view of the crew and passengers on the ferry, which was making its way back to Rocky Hill from the Glastonbury shore.

Captain Jim Grant, now on high alert, realizing that a life-or-death scenario was playing itself out, maneuvered the towboat and barge as close to the submerged automobile as was safe. His mate, Neal Wholey, a nineteen-year-old college student who had extensive lifeguarding and first aid experience, stripped off his shirt, shed his shoes and dove from the rail of the barge and swam to the car that was almost full of water. He pleaded with the driver, who sat in the driver's seat with tears streaming down her face, to unlock the doors of the vehicle. She refused as the water level threatened to fill the passenger compartment completely. Finally, she relented, and Wholey was able to bring the still conscious daughter to the surface and safety. When he returned for her mother, accompanied by local firefighters and divers from a local dive shop, she had lost consciousness. Unfortunately, she never regained it and was pronounced dead at the scene. The distraught daughter was brought to an area hospital for observation.

Not all of the mishaps regarding the ferries occur on the water. In 2015, the Department of Transportation was upgrading its communications systems, and a couple of tweets that were meant to stay in-house were inadvertently sent off to the world at large. The first tweet said, "Ferry

Update: Rocky Hill Ferry sank to the bottom of the river after being struck by the Chester Ferry." This bit of shocking news was followed quickly by the scoop, "Ferry Update: Chester Ferry ran out of fuel and went out to sea." A very embarrassed state bureaucrat explained, "There is nothing wrong with the ferries. The ferries are not running due to high water on the Connecticut River. Hopefully there won't be any more stupid Tweets coming out of the DOT. They were part of a test, and never meant to be sent out to the public. We will work on the problem and make sure that nothing like it ever happens again."

NO FARE!

Ferries and ferrymen appear in many of the world's mythologies. Their stories are archetypes of change and transformation, the transitions between one state of being and another. Very often, they tell tales that reappear over and over again in ferry history and lore. One such myth features the Viking god Thor and an obstreperous ferry captain named Harbard. As the saga goes, Thor was returning home after battling in the Land of the Giants. He comes to a swollen river and sees Harbard and his ferry on the opposite bank. He calls out to the boatman to come over and pick him up, but the ferry captain begins to shout insults across the water, mocking the hammer-wielding hero for the shabbiness of his clothes. He says that someone so poorly dressed would never have the fare to pay for his passage and suggests that the god walk all the way up to the head of the river and come down the other side. Thor does exactly that.

Slow forward to the end of the eighteenth century up in the bucolic leas of rural New Hampshire. A familiar figure on the lanes and paths around Lebanon was a Revolutionary War veteran named Jonas Lincoln. The war experiences of poor Jonas left him with the early American version of PTSD, and he was never able to quite make the transition back to civilian life after he mustered out of the army. He did merit a small pension, however, so he was able to scrape by without the necessity of working for a living. The war had left him so unsettled that he spent his days (and nights) tramping around and "stirring about."

According to an article in an 1869 issue of *Maine Farmer*:

He was a harmless, good-natured, cider-drinking, story-telling old fellow, whom everybody was glad to see, chatted with, laughed at and pitied, for he was alone in the world, a sad condition, which he took very philosophically, consoling himself by sagely commenting on all the ills which married men and heads of families are heir to.

Though usually idle and vagabondish in his habits, he was a man of wonderful energy and perseverance when his spirit was up. On one occasion when he had extended a ramble to the vicinity of Hartford, Connecticut, he found himself at the ferry, opposite the city, without a shilling in his pocket. He proposed the ferryman allow him a free passage, promising to pay on his next visit. But the Yankee Charon refused, with a churlish, "No mistah, I don't take you or no other tramp for nothing. So down with your rhino [an idiom for pay up] *or clear out." "Waal, then," exclaimed the old soldier, "you go to thunder with your old skow, I won't be beholden to you or anyone of your sort; for I'll just go around your darned old river, just see if I don't."*

The ferryman laughed at what he thought to be an idle threat; but some weeks later he was accosted at the city landing, by the same red-cheeked, roughly-clad, old soldier, who triumphantly exclaimed, "Waal, I have been all around your old river, and here I am, in spite of you, you old skinflint." It proved that he had actually performed the exploit of following the Connecticut River to its head, of going around it, in fact, with no other incentive than the desire to show himself independent, like Thor, of the ferryman.

Old soldier Lincoln, as well we might imagine, was not the first nor the last impecunious traveler to try and talk a ferryman out of his fare. At the turn of the eighteenth century, the fare for a man and a horse at Brockway's Ferry in Lyme was pegged at three pence. One sunny summer morning, a local fellow, who was known to be a bit of a deadbeat clambered aboard the scow leading a horse that was "little more than a bag of bones." When the ferryman demanded his fare before setting off across the river, the bumpkin attempted to cadge him into delaying payment until his return trip that afternoon. He suggested that he could leave his skinny old steed behind with the boatman as a pledge of remuneration upon the completion of a round trip.

"Oh naw, yer don't," responded the ferryman. "That horse ain't worth his fare, no more than you're worth yourn." After a bit of grumbling, the would-be free rider dug deeply into the pocket of his much-patched canvas trousers and reluctantly handed the ferry handler three well-worn copper pennies.

Prior to the construction of bridges across the river, wayfarers without the ways and means to secure their passage were faced with a real dilemma if they couldn't scrape up the fare. Some less than scrupulous operators took advantage of that situation and, on occasion, would raise fares at their whim or engage in outright price gouging. It is one of the reasons that local and, later, state governments regulated ferry operations and fares as far back as the seventeenth century.

The fares for ferries were set by statute. If a passenger (or his horse, ha ha) had ready cash, there were discounts to be had. But cash was often hard to come by in colonial Connecticut. As a result, payment to the ferry operator was often "in kind," basically some form of barter or trade. The medium of payment could be grain, corn, pork, beef, fruits or vegetables. In what must have been a tremendously dicey guessing game, the general court set values for each of several commodities.

Fare shunners were not the only pecuniary problem facing ferry operations. In an interesting footnote to the festering animosity between Great Britain and the Connecticut colony, William Dudley and Ambrose W. Whittlesey sought legal relief from a burden imposed by His Majesty's government. During the early eighteenth century, officers of the king of England were a "source of great annoyance, travelling at uncomly hours and paying no toll." As resentment among the nascent Americans grew toward the occupying army of imperialism, Dudley and Whittlesey sought redress from this financially unfavorable practice. The Saybrook to Lyme service owners petitioned the general court to end the practice of free rides for the "Lobsterbacks." The other alternative they proposed was to have the court give them the opportunity of raising their fares to compensate for the income lost while ferrying British officers.

The general court ultimately decided that a fare increase would be the best means of resolving the issue. Not wishing to antagonize the British, yet sensitive to the ferrymen's bottom line, it ruled that the new rates should be "thirteen pence money for man, horse, and load in the months of December, January and February, and nine pence during the rest of the year." The ruling somewhat took the sting out of the galling practice of free rides for the British, but the growing dislike for the occupying army was exacerbated by the decision. The Brits crossed the river at no charge, while the colonial men manning the sails and sweeps gritted their teeth and bore their dissatisfaction.

After the colonies won their freedom from the mother country, free ferriage was granted to certain state and county officials. Governors, deputy

governors, their assistants and representatives could all cross at the public's expense. Magistrates and deputies of the general court, along with their attendants, could also cross gratis, providing each man had no more than one horse. The free riders had to be on official business of the court. Of course, they could say whatever they were up to at the time was official business. The ferryman, who probably seethed in subdued anger over this arrangement, would later be reimbursed, if he were lucky, from the public treasury. The ferrymen were granted tax abatements to reimburse them somewhat from this loss of revenue.

One group of nonpaying passengers that never reimbursed the ferryman was members of the clergy. In the seventeenth century and well into the eighteenth, Connecticut was essentially a theocracy. The Congregational Church was not only responsible for the spiritual well-being of its residents; it also controlled much of the state and local governments. Since the clergy could argue that they were always about God's business, free passage on the ferry was their right and privilege. Given the power of the church in the community, the ferryman had little choice but to provide free passage for the parson. As the state became more religiously diverse, this practice fell out of favor.

In an attempt to bolster the nascent postal service, an act was passed in October 1729 to grant free passage to mail carriers. Some 250 years or so later, the Rocky Hill–Glastonbury ferry and the U.S. Postal Service teamed up to provide a unique service in celebration of America's bicentennial in 1976. The idea was to have the ferry become its own post office. A special stamp and envelope, with a description of the ferry, was available for thirty-five cents. This included the ten-cent stamp. The letter would be transported across the river. Upon arrival on dry land, the special waterborne piece of mail would be processed at a regular post office and sent on its way.

The purpose was to raise funds for the bicentennial activities. To enhance fundraising, a ten-dollar donation entitled the generous giver to add the title "postal inspector" to his or her name. More money was raised at an auction that took place at Rocky Hill Town Hall. The prize was the highly sought honorific "ferry postmaster general." With tongue in cheek, the chairman decided that the winner must be "a resident of Rocky Hill, and of good moral character," as judged by the Bicentennial Committee. The chairman of the committee allowed that good moral character meant someone who could outbid his or her neighbors. Also, the position mandated a certain amount of equestrian skill. The ersatz postmaster general honorific came

with the requirement that he or she must carry the first mail pouch from the center of town to the ferry on horseback.

The stamp and coin editor of the *Hartford Times* (a long defunct evening newspaper) opined that the stamps and envelopes would become collector's items. There was hope that the practice would continue beyond the bicentennial to fund other historical projects. It is unclear whether that occurred. In an amicable cessation of riparian rivalry, Glastonbury postal officials pledged full support to their Rocky Hill counterparts to celebrate the bicentennial. This unique activity recalls the historical importance of ferries transporting vital information throughout the colonies, and later the states, before the construction of bridges and the invention of the telegraph. Political and military intelligence and other socially important data (gossip, for example) could only be sent across rivers by ferries. This function was of particular urgency and import during the Revolutionary War.

As early as the seventeenth century, ferry keepers grumbled and groused about the set rates of fares foisted upon them by the government. Of course, the temptation to remedy this situation was to charge more than the going

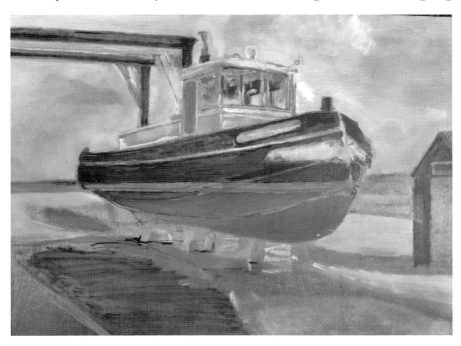

A painting of the towboat *Cumberland* in the Impressionist style by Old Lyme maritime artist Frederick Schavoir. She is rendered here just before making her yearly "splash." *Photo by Jennah E. Smith.*

rate. The traveler had to cross the river, and very often, the ferry was the only available option. More than one Charon, aware of this bottom line, overcharged a hapless sojourner who had no choice but to pay up or go many miles out of the way. To combat the practice, in 1695, a law was enacted to fine the greedy ferryman five shillings for every offense. This was not a sufficient sanction to deter the practice. A couple years later, the fine was raised to twenty shillings, half of which went to the complainer and half to the public treasury.

Fast-forward to the twentieth and twenty-first centuries. Captain Jim Grant relates that kids from Rocky Hill used to take the ferry over to Glastonbury and spend all their change over there on candy and whatnot. They would then have to beg him to return them back over the river. Of course, every once in a while, a customer would forget a wallet, and Jim would dig into his own pocket to cover the cost of the passage. It reinforced his faith in human nature that over 90 percent of the folks whose fares he fronted came back and repaid him. Farmers would often attempt to initiate an ad hoc barter system. They offered blueberries, strawberries, peaches, apples and pumpkins in lieu of coin of the realm. Although not exactly within the parameters of state regulations, the crew sometimes took advantage of that tradition from a bygone era.

Not all nonpaying passenger stories ended so amicably. Captain Grant relates the tale of the day that an accident on the Putnam Bridge that connects Wethersfield and Glastonbury created an unprecedented demand for passage on the ferry.

Cars were backed all the way up to the package store in South Glastonbury. The lines were so long that the wait time was up in the two-hour range. The people who finally made it onto the boat told me that some fights had broken out as some impatient folks tried to jump the line. The police were called to come and calm things down. One woman, when she finally got on the boat, refused to pay because she had to wait so long. She wasn't very nice about it, either. Since her car was already aboard, we took her across, and she peeled away in a huff of unpleasant language. Later that day, the state police appeared at her home with a bill for her fare. Her husband came by the next morning and paid up.

Changes in the technology of currency also create situations wherein a customer, although flush with plastic, does not have the requisite coin of the realm to reimburse the State of Connecticut for a boat ride across

the river. With the advent of credit cards and the dawning of the cashless society, situations are increasingly common in which the driver is carrying no cash, only to learn that the ferrymen do not have the means to process credit card transactions. Since their cars are usually already boxed in, the crew has no choice but to accept the passenger's solemn promises that he will make good on his passage, either through the mail or another visit to the boat, cash in hand.

The other payment problem that arose in the past few years is the proliferation of Benjamins. When a wayfarer proffers a $100 bill, or even a $50, for his $5 fare, the crew does not often have the ability or the inclination to make change. As Captain Tom Darcy asserts, "When fares were a quarter, a 20 would often get you a free fare, due to lack of change. Today, it's the 100 that will get you across. If you don't want to pay, wave a big bill in the mate's face, and you will get a free ride." These days, the ferry folks seldom suggest that a would-be nonpaying customer hike all the way to the Canadian border and back down again to avoid payment for passage.

DON'T PAY THE FERRYMAN!
(IF HE DOESN'T DO HIS JOB, THAT IS)

While state government from the early seventeenth century onward enacted a series of regulations and laws concerning ferries, it wasn't until October 1812 that the legislators felt the need to codify conditions that might warrant closing a ferry service due to malfeasance of its operators. "An Act Relative to the Middletown Ferry" was passed at that time. It states that commissioners of the Middletown-Chatham ferry have the authority to point out, in writing, to the selectmen of Middletown any defects or deficiencies they might find in the operation of the vessel. The commissioners would then be responsible for rectifying whatever defect or dereliction might be found, but the City of Middletown would have to foot the bill.

In the stilted legalese of the day, it was stipulated that should a commissioner "find any ferryman negligent in his duty, in attending said ferry, or unqualified for the same, they shall have the power to suspend or displace such negligent or unqualified ferrymen." Once again, he must state his case in writing to the selectmen but, having done so, can suspend or displace the miscreant(s). The negligent crewman (or captain) would have to serve out the term of his suspension but might also be dismissed outright. In that case, "the town shall thereupon immediately employ another man to attend the ferry: and the number of ferrymen to attend each boat shall be prescribed by the commissioners." Again, the commissioners had the say, but the selectmen wound up with the bill.

Not all cases of alleged unprofessional ferrying were easily disposed of, however. They could wind up in contentious he said/she said debates that required arbitration. The system of ferry commissioners was still in place almost one hundred years later, when the Rocky Hill–Glastonbury operation required their wisdom to settle the matter of several complaints that issued forth from a variety of citizens and shippers who were none too pleased with the service that Captain Ellis provided between the two towns.

A large contingent of complainers railed against the hours kept by the captain. The law stated that the ferry was supposed to run between sunrise and 9:00 p.m., seven days a week, but several people said this was not being done. They felt that the ferrymen had violated the terms of their contract and that it should be rendered null and void. One after another, residents bemoaned the fact that the ferry was often closed all day on Sundays and service was suspended hours before it should have been. The representative of the Businessmen's Association said that the ferry was shut down between 12:00 and 1:00 p.m. As a result, travelers often had to wait for an hour before being able to cross, often at great inconvenience. He also complained that the boat would stop running when there was a very slight fog on the river, certainly not anything that he felt should impede navigation.

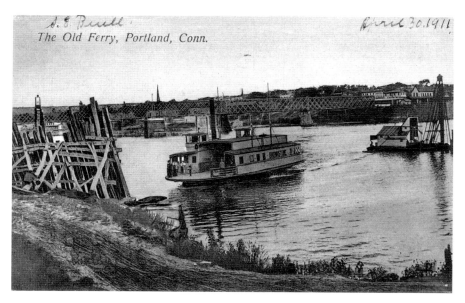

The ferryboat *Brownstone* ran between Portland and Middletown for many years until the Arrigoni Bridge made the service redundant. *Courtesy of the Connecticut River Museum.*

The ferrymen countered that the boat was only tied up on "stormy Sundays." It was then impossible to transport teams, but they gladly would row foot passengers across, weather permitting. They groused that the people who had come to air their grievances were chronic complainers and wouldn't be satisfied whatever they did to get them across the river. One of the complainers then said that the quality of the ferry service was nowhere near the equal of what it had been just a few short years before and it was, in fact, the worst service on the Connecticut River.

Walter Bush from Meriden said he arrived at the ferry one Sunday only to be told that the boat was laid up for the day. He clearly saw that steam was up in the boiler, although the captain told him that the engine was taken apart and was in pieces. After a very contentious give and take, Bush was finally rowed across the river. J. Hale of South Glastonbury bemoaned the fact that inconsistency in the schedule "resulted in his teams getting home late for dinner and this demoralized the work of his teams for the day." He also was angry that in September, he requested the ferry run at 8:00 p.m., as he wanted to get a "car loaded with some special fruit." The ferrymen said they would not run after 6:00 p.m. But they later sent word that would run up to seven o'clock to accommodate him. But he got word too late, as he had already sent his hands home for the day. He added that the incident cost him a pretty penny.

One after another, the complaints piled up against the outnumbered ferry operators. William Hurlburt had his Fourth of July celebration dampened when he asked to be transported across the river, only to be told to "Go to Hell!" by the captain. On another occasion, Hurlburt asked the captain to run the boat fifteen minutes later than usual to accommodate a time-sensitive load of produce. "Not by a God damned sight!" was the ferryman's response. Hurlburt told of three or four nights when he had to keep his teams on the Rocky Hill side, at great expense and inconvenience. The kvetching continued and included testimony that accused the captain and crew of price gouging.

Finally, the captain spoke in his own defense. He vigorously denied that he had ever charged excess ferriage to carry people across the river. He claimed that it was not always safe to run the boat on dark nights, only when it was calm and moonlight showed the way. Safety was always his paramount concern. He said the new boat he used was much more difficult to maneuver than the old one, and he would be glad if the previous captain would come aboard and give it a try to see just how hard it was.

He swore that he lived up to his contract to the best of his abilities and only closed when forced to by wind, ice, squalls, snow or fog. He admitted to some confusion as to whether he was allowed to shut down operations on Sundays and now saw clearly that he was obligated not to do so. He regretted that he had abused Hurlburt but said the former was impolite to him also. A Captain Alvin Taylor from Chester, an experienced ferryman and fisherman who had filled in as captain of a few runs of the new boat, spoke in Ellis's defense, saying the new ferry "was about the hardest boat he had ever seen." He agreed that the boat should not be run in adverse weather conditions. The ferry commissioners mulled over the testimony and, in grand bureaucratic tradition, reserved their judgment for another day.

THE WAITING GAME

One important aspect of ferry service across the Connecticut River has been pretty much unchanged over the course of four centuries: passengers must wait a bit before the ferry arrives from the opposite bank. One of the most common complaints against colonial ferrymen was that sometimes they never showed up at all, which left their potential customers in the lurch. Of course, this was somewhat balanced out when competing ferrymen would race across the current to be the first to collect the fare. Waiting for the ferry remains, to this day, an exercise in patience and buoyant good humor. It also reveals some interesting intersections of socioeconomic and class status among the anxious would-be travelers.

Over time, there have been several means of summoning a ferry to the preferred side of the river. Passengers could ring large bells, blow into Alpine-style horns, beat on pots and pans or simply yell at the top of their lungs to get the ferryman's attention. With the coming of the age of the automobile, foot pedal–operated claxons, or horns with squeeze balls, could make the requisite noise. When these noisemakers became mechanized, signs appeared on the riverbanks, advising motorists to "Sound Your Horn to Call Ferry." Creative drivers would sometimes send Morse code messages across the river by means of flicking their headlights on and off. Emergency vehicles and some commercial traffic can make arrangements for pickup using radios. Cellphones now add another dimension of communication between boats and shore.

Regardless of how they are signaled, ferrymen still must take note, cast off and cross the river to pick up those who wish to cross. Depending on

A young lady peals the bell used to summon Bissell's ferry from across the river. *Courtesy of the Connecticut River Museum.*

weather, mood and inclination, the crew can be prompt in their response or take their sweet time, in hopes that more customers will appear on the opposite shore to make their trip more lucrative and diminish the necessity of making an extra trip or two. Those waiting let out a collective sigh of

relief when they see the boat across the river leave its slip and finally head in their direction. Ferry waiting is not for the very impatient. Part of the charm that captains and crews speak of is the relaxed, non-hectic atmosphere that makes ferry travel a pleasure.

That being said, there are times when waiting in long lines of traffic for a ferry can result in stressful situations. Traffic accidents and construction projects (especially on bridges) can result in traffic being rerouted onto the ferries. This causes inordinately long wait times as cars back up, literally for miles on the tiny country lanes that mark the approaches to the ferries. Tales of fistfights breaking out between line jumpers and road rage of the slow-going variety are not uncommon in these situations. Jim Grant reports that some impatient patrons exchanged heated words, and one of them brandished a pistol.

When the long-suffering motorists finally do make their well-deserved arrival aboard the boat, the captains and crews are sometimes the targets of their verbal abuse. Obstreperous passengers are seen as just part of the job and are usually shrugged off by the crew. But ferrymen are only human. The passengers rarely think about the fact that the crew has a radio that could alert the constabulary to await the miscreant with a summons or handcuffs. Crewmen and clients have been known to exchange fisticuffs on occasion.

For the most part, however, ferrying is a peaceful pastime. On summer weekend afternoons, tourists enjoy the ambiance of Hadlyme or Chester as they await their turn on the boat. Adults and children will get out of their cars to take in the river scenery and watch the passing boats. Every once in a while, Mom or Dad will get back in their vehicle and move up the line as they edge closer to their time on the *Selden III* or the *Hollister*. In the past, just as today, these waiting periods provided travelers the opportunity to display their socioeconomic class status by means of the vehicle (or lack thereof) they operated. Car-obsessed Americans love to show off their rides, and the ferry line is a time-honored place to do it. An article dated 1908 tells of statesmen, artists, financiers, poets and just plain folk all waiting for the same boat. But it also details the differences between "the roadsters maneuvered by a goggled chauffer, and the one horse shay of those still in the agricultural age." Apparently, the class-conscious "autoists" somehow felt that they should have priority over horse-drawn traffic. But democracy held sway at the slip, and the "first come, first served" rule was applied democratically.

As cars became more prevalent, ferry crews began to pay attention to the differences in makes and models. The famous quip of an East Haddam captain that his vessel could accommodate "five automobiles or four Fords"

was recapitulated years later when a mate on the Hadlyme boat said it could "carry eight cars or ten Volkswagens." Ferry service does provide the opportunity to observe some vintage automobiles. A classic car show or parade on one side of the river can produce deck loads of ancient Rolls-Royces or mammoth Packards that hark back to the days of genteel motoring when ferry passengers weren't in such great hurries.

As bicycling grew in popularity at the end of the twentieth century, the ferries became parts of long-distance bike routes used by riders from all over New England and New York. On a summer afternoon, a tent set up by bike organizations can be found in the parking lot in Hadlyme, passing out water and sandwiches to dozens of long-distance riders on organized trips. One bike shop in Connecticut sponsors a 2-Ferry Ride that has loops of either sixty or one hundred miles that traverse the river on both of the boats.

Dozens of cyclists waiting for the ferry, along with a few dozen cars, present some social and logistical challenges for captains and crew. Who has precedence: motorists who pay more or bicyclers who certainly take up less

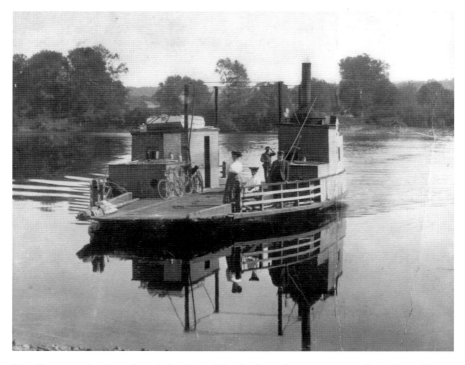

Bicyclists cross the river aboard the *Nyaug*. The ferries today are very popular with cyclists. One Connecticut bike shop hosts 2-Ferry Rides of sixty or one hundred miles that feature crossings on both boats. *Courtesy of the Connecticut River Museum.*

space? The certificate of inspection for the *Selden III* requires that there be no more than forty-nine people on board, including crew. The number of cyclers per trip is limited by that fact. Some captains are sticklers and adhere strictly to an even split of bikers and other passengers. Others will say the hell with it and bunch more bikers aboard but never exceed the number of life jackets available.

Experienced ferry travelers say that the trick to enjoying a successful wait is not to be in a hurry. They recommend practicing a mindfulness that allows you to appreciate that by waiting for a ferry, you are participating in a human activity that spans millennia and almost always results in an excellent boat ride. They recommend observing the cabin cruisers and canoes on the river or doing some bird (and people) watching. Ferry aficionados believe that the wait and anticipation heightens appreciation of the boat ride when finally on board and underway.

CHAPTER 9

BRIDGES
(MOVEABLE AND OTHERWISE)

Ferryboats are often referred to as "moveable bridges." In fact, the two remaining ferries on the Connecticut are both legally designated highways. They are parts of State Route 160 between Rocky Hill and Glastonbury and State Route 148 connecting Chester to Hadlyme. (They are the only highways in the state where the automobile speed limit is zero.) Ferries and bridges share functionality. Their primary purpose is to transport people, vehicles and cargo from one side of the stream to the other. Each mode of transportation has its advantages and disadvantages. Overall, it would appear that bridges overwhelmingly won the trans-riparian rivalry. But ferries still hang in there and, hopefully, will continue to do so for a good long time.

During the age of agriculture, ferries were the primary means of crossing the river. They were relatively inexpensive to build and maintain. They relied on cables, sails, horses and oars; they did not require expensive machinery or fancy slips. Their operational downsides, of course, included floods, wind, fog, debris, ice, low water, currents, darkness and the whims of ferrymen. Those problems notwithstanding, ferries were how one crossed the Connecticut for almost two centuries after European settlement. The ferryman was an important member of the community and provided a valuable service.

The opening of the 2017 season in Rocky Hill–Glastonbury was delayed by high water in April. This is not unusual, but the freshet lasted almost two weeks. The ferry was subsequently shut down on several more occasions lasting well into July due to too much water. When the river is up, the barge ramp cannot safely align with the shore. *Photo by Jennah E. Smith.*

As the industrial age dawned, innovative tool design and woodworking skills resulted in some tentative wooden bridges across the Great River. They had obvious advantages. They could be used at any hour. They were not susceptible to wind, low water, fog, currents and ferrymen's whims. They did have problems, however, with flood, decay, ice and fire. Once wooden bridges were replaced with steel spans, the age of ferries on the Connecticut came close to its end.

The first wooden bridge across the river was built in 1808 and connected Suffield and Enfield. It withstood the ravages of floods and ice for nearly a century before it was washed away in a great spate at the turn of the twentieth century. As fate would have it, it came loose from its moorings just as bridge inspector Hosea Keach was walking across it to determine if it was safe. Keach got the ride of his life. He climbed to the top of the structure as it careered down the raging torrent. The bridge broke into ever smaller pieces as it went. The terrified inspector prepared to meet his fate and screamed his head off. Fortunately, he was heard, and bystanders on the riverbank were able to get a rope to him and drag him to safety just before the remnants of the span disintegrated.

The year 1808 also saw a bridge erected between Hartford and East Hartford. This caused perturbations between the two communities due to the differences between tolls on the bridge and fares on the ferries. Those differences resulted in drawn-out legal battles that eventually found their way to the Supreme Court. The bridge company demanded that ferry service be discontinued, claiming a monopoly on river crossings granted by the state legislature. This claim became moot after the bridge suffered major damage in 1818, and ferry service became the only viable means of crossing the river.

The Town of East Hartford claimed that the bridge's monopoly placed its citizens at an economic disadvantage because essentially ferries were cheaper. Hundreds of thousands of words in legalese and countless hours of courtroom battles ensued. There was a socioeconomic dimension to the legal wrangling. East Hartford supplied a significant amount of Hartford's labor and felt that the workingman should be able to cross the river as inexpensively as possible. The arguments were to no avail, however, and the Supreme Court ruled in favor of the bridge company.

Ironically, East Hartford exacted a bit of revenge several decades later when the bridge burned. Ferry service once again became the primary means of crossing between the communities. Ferries from East Haddam, including the iconic steamer *F.C. Fowler*, were diverted upriver to keep the vital flow of workers coming into the city from its suburbs to the east. It is said that Governor Morgan Bulkeley mandated that the ferry slip be in front of the River House, Hartford's premier upscale brothel at the time.

The proliferation of bridges across the river foreshadowed the demise of many ancient ferry services. In the instance of the completion of the span

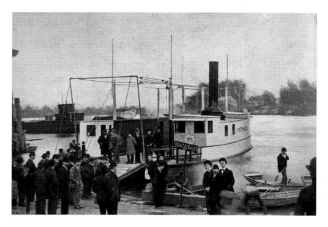

The ferryboat *F.C. Fowler* was brought upriver to Hartford in 1895 when the wooden bridge between Hartford and East Hartford burned. It notoriously provided services to the customers of the River House, Hartford's most famous maison de joie. *Courtesy of Captain Larry Stokes. Photo by Jennah E. Smith.*

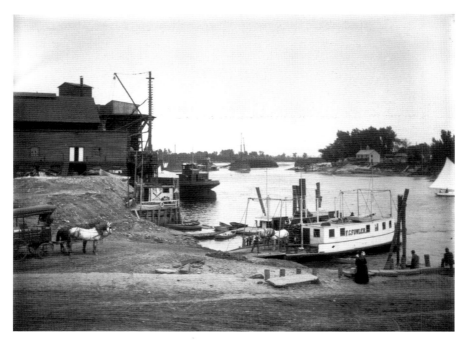

The *F.C. Fowler* has just loaded a horse and buggy bound for East Hartford. *Courtesy of the Connecticut Historical Society.*

between Old Lyme and Old Saybrook in 1911, it was seen as a boon for both towns because it relieved them of the financial burden of maintaining an expensive ferry service that neither town found beneficial. There was very little traffic between the two hamlets. Most of the ferry traffic was from out-of-town travelers who used the vessel at low cost. It is reminiscent of the twenty-first-century argument that out-of-state motorists should pay tolls on Connecticut highways as they pass through the state.

The East Haddam Bridge caused the end of the old Chapman Ferry in East Haddam. It was built as the result of a determined effort on the part of local businesswomen and men to give a boost to the town's economy. The Bissell ferry was soon to follow Chapman's into oblivion as the river was spanned between Windsor and South Windsor. The Rocky Hill–Glastonbury service remained even after the completion of the Putnam Bridge because it provided access to the railroad for feldspar and agriculture products from Glastonbury. The Chester-Hadlyme service stays on as a tourist attraction and can still save a driver several miles during the season.

THE SWORD OF DAMOCLES

Since early colonial times, ferries on the Connecticut River have been operated by private individuals or companies. However, the rates they could charge customers and other aspects of their operations were closely regulated by the colonial and later the state government. For a few hundred years, ferries ran at some level of profit for their owners. Not always, but they usually wound up somewhere in the black. The question of profit became more complex with the advent of steam ferries and the automobile. Steam ferries were exponentially more expensive to build and operate, as opposed to the simple oar- and sail-powered scows that had plied the river for centuries.

At the beginning of the twentieth century, these problems caused the towns of Old Lyme and Old Saybrook to approach the state legislature's committee on roads, rivers and bridges in hopes of obtaining some fiscal relief because service between those communities was now running in the red. Three bills were presented to the committee. The first called for the maintenance of the ferry to be transferred to the state; the second suggested that New London and Middlesex Counties should take over the operations; while the third provided that the state would make up any deficit the towns should incur in running the ferries.

Both towns agreed that the operating deficits of almost $1,000 per year for each village were unsustainable. Lawyer D. Eddie Griswold of Old Lyme argued that the boat between Old Saybrook and Old Lyme presented special circumstances that required relief from the state. He acknowledged that

ferry service between Hadlyme and Chester, East Haddam and Haddam, Middletown and Portland and Rocky Hill and Glastonbury all ran at a profit. This, he reasoned, was not possible at the mouth of the river because swift currents near the railroad bridge obliged the towns to buy a $2,500 ferryboat instead of the customary $1,500. The extra torque was necessary to overcome the power of the swirling water.

The installation of the railroad bridge had changed the nature of the ferry business at the mouth of the river. Passengers could cross the river by rails for only five cents, making the business of "footmen" a thing of the past on the boats. Most of the travelers on the boats were now transients in automobiles and carriages. The ferry no longer was used by residents of either community. The lawyers argued somewhat speciously that no one in Old Saybrook worked in Old Lyme and vice versa, although the first selectman of Saybrook did allow that sometimes one of his citizens would go to Old Lyme to buy cattle. The ferry, they reasoned, had become a convenience for summer swells in fancy vehicles on the way to the "Vanderbilt Races" and other frivolities. Some salesmen and "junkmen" from New Haven and New London used the ferry, but most passengers were from "away."

In good political fashion, the legislators tabled the various proposals and kicked that can down the road for future legislators to contemplate. But this exchange marked the beginning of the end for the centuries-old ferry service at the mouth of the river. The eventual construction of the automobile bridge between the two towns sounded the final death knell. The superannuated steamers were no longer a necessary convenience. Before the bridges, a trip between the towns by road was twenty-five to thirty miles long, but the bridge made it a matter of mere minutes.

The need for larger, steam-powered vessels to accommodate the age of automobiles and trucks began to place economic burdens on other ferries up and down the river. The increasing numbers of cars created increased demand for bridges, which ultimately replaced ferries at several locations, including Windsor, Hartford, Middletown and Portland. As attrition eliminated ferry service after ferry service, the only two to remain standing were Rocky Hill–Glastonbury and Chester-Hadlyme. As the Roaring Twenties approached, it became incumbent upon the State of Connecticut to completely take over the operations of both of these ferries, an arrangement that it has maintained uneasily up to the present day.

As of this writing, it has been one hundred years since the two remaining ferry services on the Connecticut River were taken under the aegis of the State of Connecticut. As ferries discontinued service one by one, due to

the proliferation of bridges and the speeded-up lifestyle brought on by the age of the automobile, private operators no longer found it financially feasible to stay in business. The state stepped in to provide economic and logistical support for the Rocky Hill–Glastonbury and Chester-Hadlyme boats. Once this occurred, legislative and citizen watchdogs, intent on saving every taxpayer penny possible, began campaigns to shut down all ferries in the name of public sector economic prudence. As a result, the Connecticut River ferries have endured periods of existential fiscal crisis periodically for almost a century.

Strategies on the part of politicians to put a period to the service include raising fares to levels unacceptable to the public; cutting and eliminating staff to decrease the number of days and the number of hours per day that the boats run; creating inconvenience for commuters and confusion for the general public; and, when those plans weren't enough to achieve their ends, just shuttering the operations once and for all. As we shall see, so far, none of these strategies has worked. The ferries still continue to chug across the river as they have for centuries. The primary reason they still exist is the enormous support they generated from an organized and vocal constituency of concerned citizens who rally in the name of grass-roots democracy to keep their beloved boats operating on the water.

The first major assault on the ferry service occurred in September 1925, when it was reported that the two remaining lines were "conducted at a loss." That loss was to the tune of $14,650, the equivalent of $210,000 in 2017 money. Interestingly, the Chester boat lost the most money by far— over $11,000, as compared to $3,000 for Rocky Hill. Consider, however, that since the state budget was much smaller back in 1925, the percentage that the $14,650 represented was much greater. It was the first time that politicians began chanting the chorus "Close the Ferries, We Can't Afford Them." A coalition of citizens, many of them farmers, lobbied their state representatives to keep the service afloat. At that time, there were still wagons that needed to cross the river to get produce to market. As the blossoming automobile age took over, they slowly faded from view. But back in 1925, agricultural interests still had some clout in the state legislature.

A point of interest in the 1925 report about the ferries' fiscal year was the note that all of the 2,518 cars that crossed the river at Rocky Hill were registered in the state of Connecticut. On the other hand, of the 7,901 cars that crossed in Chester, 7,278 were from this state and 623 were "foreign" (meaning out-of-state) cars. This statistic began to give some credence to the argument for saving the ferries, as they (at least Chester-Hadlyme) were

tourist attractions that generated revenue by bringing out-of-state dollars into Connecticut. While those dollars didn't appear on the service's bottom line, advocates for the ferries realized they were an important reason why the little vessels should continue on the river.

In 1938, a serious attempt to close the ferries resulted from a territorial dispute between factions in the State Highway Department in a turf war over power and dollars. Republicans from towns nowhere near the ferries agitated to end the service for economic reasons. Groups within the Highway Department agreed with them, and a measure to "abandon" the ferry service was introduced in the House of Representatives. But "when the measure was given a public hearing by the legislative committees on reorganization, legislators, businessmen and citizens of the towns in the vicinity of the ferries protested and marshalled legislators from distant sections of the state to join in their expression of opposition." Faced with a groundswell of support for saving the ferries, those who would have abolished them withdrew their measure, and the boats were free to motor across the river once again.

This core of opposition to closure of the ferries was able to stave off other half-hearted attempts, but in the 1980s, those who would shutter the service regrouped and sharpened their pencils. In 1982, a state budget crisis goaded the Department of Transportation into taking action against the boats. Citing a $100,000 deficit, the director of the Bureau of Waterways said, "You couldn't make money on this type of line. We continue to operate it because it provides a limited transportation service and because of its cultural and historical significance." He noted that "75 percent of summer passengers are tourists, who add dollars to the state economy." A member of the Planning and Zoning Commission of Rocky Hill iterated opposition to closure, saying, "There would be a revolt in town" if such a thing came to pass.

In 1989, the state eliminated the granting of season passes as a means of reducing revenue to justify its aim of ultimately closing the ferries. According to a deputy transportation commissioner, "That season pass was a gift; I don't know why it was ever offered." Up to that point, regular users of the ferry were able to purchase a pass for twenty-five dollars, which enabled them to ride across the river all season long without any further expense. The season pass was replaced with a ticket book that allowed the buyer to enjoy forty trips for twenty dollars, a 50 percent savings. The cost of a one-way trip was also raised from seventy-five cents. It was the first increase since 1980. Walk-on fares remained at twenty-five cents, but for

the first time, that was good for only a one-way passage, not the round trip, as was previously the case.

The deputy commissioner insisted that the half price was still a bargain, but riders who used the ferry five days a week complained that it was a real financial burden. "It's gonna cost me over $150 to ride the ferry this year," moaned one Glastonbury resident. "I just don't know if it's worth it anymore. I will spend more on the ferry than I do on gas going around all winter." Several commuters reluctantly allowed that they might have to give up their yearly routines and just use bridges. For some, this would bring an end to an "almost spiritual ritual" of river crossing. East Haddam residents circulated a petition and garnered 252 signatures that they forwarded to Governor William A. O'Neill, their state legislators and the Middlesex Chamber of Commerce.

The deputy commissioner emphasized that the fare increases were not intended to decrease losses that the ferries had incurred in the past fiscal year. According to him, the Rocky Hill ferry lost "about $131,153 and the Chester boat ran $93,926 in the red. We just want to tighten up accountability." He claimed that 426 season passes had been sold in the past year. He then asserted that "season ticket holders were switching their commuter stickers from car to car, cheating the system."

"That's impossible," countered one commuter. Those stickers are attached with heavy glue and couldn't be shifted from car to car. A mate on the Chester boat averred that he was seeing a lot of dissatisfied customers and that he "was the one who was getting all the flak. But hey, that's my job. But it's been bad, real bad."

Four years later, yet another fare increase hit the pocketbooks of ferry passengers. In an attempt to offset a deficit of approximately $320,000 in the previous year, rates rose from $2 to $2.25, and a book of tickets jumped from $20 to $22. Yet another deputy commissioner optimistically opined that the bump in price would raise an additional $100,000 toward the ballooning deficits that the boats generated. For the first time, discount ticket books would be sold with an expiration date, valid for only the season in which the book was sold. Another innovation was a $1.50 tariff for trailers towed by vehicles aboard the ferries. In another money-saving measure, the operating year of the Rocky Hill boat was shortened. It began May 1, as opposed to its usual start-up on April 1. The first selectwoman of Portland, Bettie Perreault, called the fare increase "unfortunate," while adding that she "understands the state's need to cover the cost of service." She said that the fare increase would be felt most by commuters who crossed the river on the ferry for work.

In 1997, the specter of closings loomed once again. The state claimed that it lost two dollars for every passenger conveyed across the river. Its response was to not replace a mate who opted for an early retirement package and a captain who resigned. The decrease in staffing led to less maintenance and a shortening of weekend hours. Instead of the usual 7:00 a.m. start, scheduled service did not begin until 10:30 a.m., and the boat docked for the evening at 5:00 p.m. instead of 7:30 p.m. The shorter hours, coupled with shutdowns for bad weather, had the unintended consequence of reducing the number of paying passengers and wound up costing money rather than saving it. There was talk of trying to sell the operation to a private company. The crews of the boats held several meetings and strongly voiced their opposition to that plan. One of the senior administrators iterated that closing the ferries wouldn't be an option. "Mostly the ferries are a tourist attraction," he said. "We recognize their historical importance, so we have to take that into consideration."

But the relentless era of economic uncertainties continued. In the beginning of the 1999 season, Captain Larry Stokes of the Rocky Hill operation was asked to develop schedules based on limited hours and crew members. Staff of both ferries were kept in the dark as to what the status of day-to-day service would be. Rocky Hill was informed that it would have a four-member crew instead of the six people who previously manned the vessels. There was a chance that a part-time relief worker would be made available. But the likelihood that the boat would have to chop one day per week off its schedule morphed into reality. The state began to explore the idea of training maintenance workers from area garages to fill in as ferry mates and fill in for shift vacancies when necessary. Transportation Commissioner James P. Sullivan stated, "The department believes this proposal will be successful and will allow the ferry staff to continue the faithful service that they have provided throughout the years."

The uncertainty of job security, coupled with complicated union regulations, often created animus among crew members. There were palpable hard feelings over who showed up and who didn't. Issues of scheduling and overtime were often hot-button subjects pitting the crew members against one another and the byzantine state bureaucracy. At one point in the 1990s, a senior captain averred that all crew should take a pay cut or a wage freeze and any new hires should be seasonal, part-time workers. These observations, as one might imagine, did not always sit well with his fellow captains and mates.

This era of discontent was further exacerbated by complicated vacation schedules. Some crewmen had over two months of vacation time due to them, but they were unable to enjoy them due to staff shortages during the season. This situation was made even more unpleasant when the ferries were not running. From November 1 to March 31, the crews were considered to be under the aegis of the Department of Transportation. This severely limited vacation opportunities because if a snowstorm required it, they were obligated to report for plowing duties, both at the state's airports and on its highways.

Rocky Hill townspeople viewed the unfolding peril of the ferries with great consternation. On February 17, the mayor presented a letter to the Department of Transportation that proclaimed the town council's opposition to any cuts. It stated that the ferry was "a key piece of Rocky Hill's culture and presents a major defining image of the town....The ferry is a major tourist attraction...and generates considerable tourism dollar for the businesses in town, and is thus considered a major economic asset." The town council voted unanimously to oppose any reduction in the operating hours of the ferry. It recognized that there were "many intangibles inherent in the ferry system that need to be considered."

That same year, an argument was made against the possible shutdown of the Hadlyme-Chester service based on its importance in providing emergency medical services. The fire chief and ambulance coordinator of Lyme installed an emergency radio on the ferry "because the ferry can be the fastest way to get someone in medical need from one side of the river to get help on the other side." In its relatively short tenure, the radio was used a dozen or more times. The most frequent scenario was when an ambulance on the Hadlyme side needed to rapidly transport a patient to the hospital in Middletown or the emergency clinic in Essex. A dispatcher could radio the ferry, and it would change course to get to the appropriate shore as quickly as possible. The system also is instrumental when a health emergency occurs on the ferry itself. Captain Jim Grant tells of a woman who fainted on the boat. He was able to call the Chester ambulance, which was then able to meet the vessel as it docked to whisk the distressed passenger to the appropriate medical treatment. Hence, public safety concerns were added to the cultural and social reasons for preserving the ferries.

By 2003, the pessimism that the Rocky Hill service would be terminated was palpable. The bulkhead at the landing slip was seriously deteriorated, and sediment had filled in the riverbed to the point where navigation was greatly hindered. Hours of operation had been drastically reduced. On weekdays,

the boats began the season crossing at 7:00 a.m. and stopped running at 1:00 p.m. On weekends, there was no service whatsoever. Local residents and ferry lovers in general saw these factors leading to the elimination of the nation's oldest continuous ferry service altogether, and they weren't happy about it. The DOT communications office ominously said it was waiting until the end of the fiscal year on June 30 before making further determinations as to the future of the towboat and barge. Rocky Hill's mayor called the reduced hours "the first step, in my view, to eliminating the ferry."

The citizens realized that the ferry was not the only service on the chopping block. Financial hard times had befallen the state budget. Layoffs and early retirements eliminated many programs and services, including those that provided aid to underserved and vulnerable populations. A budget crisis had been declared. But ferry lovers fought back. An ad hoc Save the Rocky Hill/Glastonbury Ferry group formed and immediately mounted a public relations and political action campaign aimed at providing awareness to the public and applying pressure to politicians though phone calls, letters and the increasingly popular information system called e-mail. At one point, Humphrey Tyler, the organizer of the protest movement, reported that the governor's administrative assistant, who was most cordial at first, became a little petulant as call numbers rose and continued unabated. The movement was a success, and the ferry continued to survive the assaults of governmental bureaucracy.

The year 2011 found the sharpened pencils of the state bean counters pointed at the ferries yet again. And again, the citizenry responded with indignation and political organization. Hadlyme Town Hall was filled with residents and local officials raising their voices in support of the ferry service. Once again, the phone numbers of the governor and key legislators were distributed. This time around, though, a new strategy emerged. The pro-ferry forces began researching the statutes under which the service operated. They determined that the mandate that the Department of Transportation operated under considered them to be historic structures and that a published notice and a hearing were necessary before they could be closed. East Haddam, Chester and Lyme planned to file an injunction to prohibit the closings because of the potential negative impact on local transportation and businesses.

The plan was to slow down the potential layoffs to crew and give the grass-roots movement more time to organize. A riled-up crowd agreed to this tactic. Susan Tyler railed, "These ferries are not a luxury, they are part of Route 148, they are part of Route 160; they are part of the transportation

The Glastonbury Citizen • August 7, 2014

The scenic historical ferry.

In an attempt to generate revenue, the State of Connecticut allowed the ferries to be festooned with advertising. Public opinion was against the idea for aesthetic reasons. *Courtesy of the* Glastonbury Citizen.

structure and network of the Connecticut River Valley." Captains Darcy and Marshall reported how the state had had slowly cut back hours and services at the ferries, trying to reinforce the idea that the ferries were merely alternate routes and not fundamental pieces of the state's transportation system. Other residents spoke out with fears that the closing would negatively impact their property values. Once again, these efforts saved the ferry service. Militant ferry supporters, once again, deluged the inboxes of state officials and legislators to stave off the end of ferry service in Connecticut.

In 2014, public outrage once again swirled around the ferries. This time it was directed not at potential closings but at the law firm of Carter Mario. That organization had a long history of advertising on buses run by the Connecticut Department of Transportation. Its ad agency, Signal Outdoor, in response to an initiative on the part of the state to enhance revenues to help make up the half-million-dollar deficit the ferries were incurring, bought advertising space on both the Rocky Hill–Glastonbury and Chester-Hadlyme boats. The results were large banners attached to the rails of

both ferries that exhorted those unfortunate enough to have been injured in an accident to "GET CARTER!" They featured the smiling face of the entrepreneurial barrister, along with his website.

Their sense of aesthetics and proper New England decorum offended, the citizenry once again took up their torches and pitchforks. The law offices of Carter Mario were flooded with phone calls and e-mails demanding that the obtrusive ads be taken down immediately. The state received hundreds of similar calls. Mario averred that he was only trying to do the right thing to "lend a helping hand to a truly iconic part of our Connecticut River." He said that the artwork that wound up on the boats was the same as that placed on Connecticut buses but agreed that it was not appropriate for the vessels. He also claimed that it was placed by his ad agency without his prior approval.

The unpopular artwork was summarily removed from both boats. Cindy Mario, the law firm's marketing director, designed a mural using vintage ferry photographs that now graces the side of the Chester-Hadlyme boat. She agreed, "That is not the place for advertising. We have ridden the ferry in the past, and it is beautiful and serene—not the right venue at all." The ad agency defended its decision to drape the debatable banner. It said the ferry needed money to keep it operational. "They came to us because we have done a lot of advertising for charities or public service issues…and hoped we could help."

A Department of Transportation official said that the ads were certainly a shock to many since it was the first time that advertising was allowed on the ferries. But he also said that the overall concept was a good one and that the ferries need to generate more revenue, as they are perpetually on the chopping block, losing upward of half a million dollars a year. The state has an obligation to pursue every means of reducing and offsetting their substantial operating losses. He said the state would pursue the possibility of developing advertising signs at all four of the ferry slips, as well as scaled-back versions on the boats themselves. "Let's give the advertiser a chance to reshape the ads to better fit the context of the ferries before we rush to judgement. The public has spoken. This is the way it works sometimes." As of this writing, there are small posters in glass cases on the Chester-Hadlyme boats advertising events of local interest.

Other alternative ideas to supplement ferry income involve privatizing them or running them as a public/private collaboration. The town governments in the lower river valley have started conversations to this end. The executive director of the Connecticut River Museum in Essex expresses

The mural on the bulkhead of the Chester-Hadlyme ferry was placed there by a representative of the law firm that had previously bedecked the ferries with advertising banners that created quite a stir because they offended the taste of the general public. The mural depicts historic Connecticut ferries. *Photo by Jennah E. Smith.*

his dream that the operation of the Chester-Hadlyme boat be taken over by the museum and run as part of its long-standing commitment to the sociocultural fabric of the Connecticut River.

Our hope is that the economic and administrative structures will be developed to provide the resources necessary to continue the operation of the ferries. While they are part nostalgia and history, they are also vital links in Connecticut's transportation infrastructure. Our state would be diminished culturally and aesthetically should they cease to exist. Please enjoy them as often as possible so that their span of the centuries might continue.

WINTHROP "WINK" WARNER: DESIGNER OF *SELDEN III*

by *Stephen Jones*

Luck is the residue of design.
—Branch Rickey

A scroll through the gallery of early Connecticut River ferry craft will yield few architectural beauties. In fact, even to bring in the concept of architecture seems a stretch. Most of these vessels are either pathetically plain or outrageously homely, at best comic in a Toonerville Trolley way: a shack on a barge with some sort of goofy paddle-wheel box or a turnstile and mule better suited to the grinder at the Brer' Rabbit blackstrap molasses plant back of the levee south of New Orleans in 1910. The ramp at each end is rigged in what seems influenced by the sort of block and tackle gibbet contraption thrown up by lynch mobs to deal with multiple horse thieves. There is sometimes an outsize paddle or an undersized anchor or a sun-warped "lifeboat" suggesting a maritime environment. The whole notion of conscious design seems to have been ruled out as if violation of local ordinance. It was with some shock, then, that I discovered that modern Connecticut River ferryboats actually had architects and that *Selden III*, the most recent boat that plies the Chester-Hadlyme route, was designed by the prominent Middletown naval architect "Wink" Warner.

To those of us who knew him only in middle age, Winthrop Loring "Wink" Warner (1900–1987) seemed a man of iconic dignity. He spoke and dressed in a highly educated, precise way, and his manners were impeccable. His presence at a riverine event on the Connecticut was akin to having the

Wink Warner's wooden toolbox. Warner designed the *Selden III*. *Photo by author.*

Wink Warner's drafting tools. Warner was known for the beauty and functionality of both his yacht and commercial vessel designs. *Photo by author.*

bishop at a ball game. Research into his past, however, reveals him more of a child of the river than the front parlor, more Huck Finn than a Little Lord Fauntleroy, as he prowled the nooks and crannies of the lower river in an old launch that he himself seems to have made once again seaworthy. His early hands-on boat construction training began across the river at Portland under the hard blue eyes of the Holters, father and two sons of Scandinavian square-rigger background. That rough schooling was fine-tuned by four years at MIT, followed by journeyman work in the offices of iconic naval architect John Alden, out of whose office spawned such other icons as Carl Alberg, Murray Peterson, K. Aage Nielson and the leading small craft historian, indeed the inventor of the genre, Howard Chappelle. From Alden, Warner went to William Hand, where he learned motor sailers, and on briefly to Philip Rhodes for graduate work in sailboats. He finished his apprenticeship at Electric Boat in Bayonne. By 1929, he was ready to hang out his own shingle in Middletown.

In the following decade between 1931 and 1941, his office produced thirty designs from which seventy-five wooden craft were built by a number of New England yards such as the legendary Rice Brothers on the Damariscotta River in Maine. These boats ranged from dinghies to commercial draggers. While including motor sailers and outright powerboats, the characteristic Warner was a cruising sailboat, usually Marconi rigged sloop or yawl in the twenty-five- to thirty-foot range. Many of these boats entered in Off-Soundings and occasionally placed, but Warner customers preferred comfort to the competitive speed of the racing machines, which were usually tested in tacking to windward on Long Island Sound in light air. All Warner's designs are now on file in the classic plans department of Mystic Seaport.

In the definitive *Encyclopedia of Yacht Designers*, Daniel B. MacNaughton praises Warner for his "precise drafting" and points out that his designs are admired for their "striking good looks…strong sheer lines and dramatically shaped ends, with superstructures carefully made to complement their dominant curves." So appealing were these lines that my father had no fewer than three Warner designs built, beginning in 1936 with the modest twenty-eight-foot sloop *Typhon*. He would sit in his chair by the fireplace after supper and, using colored pencils on an outline of the boat supplied by Warner's draftsman Ralph Jackson, work out on a lapboard the paint scheme. Starting with the bottom, he would move lovingly up to waterline, boot top, topsides and cabin. Sometimes he would show these finished plans to my mother and me. The ones that drew the most enthusiasm went on to Warner.

Ironically, *Typhoon* went to the bottom at Dike Wetmore's fuel dock in Essex in the great New England hurricane of 1938. So well, however, had she been built and so sweet was her design that she was raised the next day and, after minor repairs, refloated. When she was yet dripping Connecticut River water, my father sold her right on the crane and with the windfall of the insurance doubled down on Warner. He ordered the thirty-two-foot yawl *Privateer* to be built by Rice Brothers for $5,500. Unfortunately, she burned up in the great Holter Portland boatyard fire during World War II. Little *Typhoon*, however, is at this writing yet afloat, having spent recent years in California and Florida. Her image is the sole illustration representing the Warner oeuvre in *Encyclopedia of Yacht Designers*.

As MacNaughton says, Warner managed to stay in business during the Depression and World War II thanks in part to the "good opinion" of the leading boating publications of the day, as *Yachting* and *Rudder* frequently featured drawings and articles on current Warner projects. The word "comfort" can be taken these days to mean the sort of boat show product designed by consumer focus groups from the inside out, with a last-minute shell slapped around the interior in begrudging acknowledgment that the object is, after all, meant to go to sea or at least give that impression at the marina. Warner's boats, however, were comfortable within the priority established by the limits of their sea-kindly lines and were meant to be comfortable when actually at sea or at least swinging to a mooring.

Wink Warner became one of my virtual uncles, friends whom my father gathered along the mid-century waterfront, and while I think of him as the epitome of a gentleman, it is his involvement with my father and two other actual uncles in a bit of what might be called "muscle display" that most stands out in my recollections of him.

The ostensible issue was the transaction between a Down East boat broker and my father over an 1885 Friendship sloop that, upon the passing of hard cash, turned out to have considerably more dry rot than my father had been led to believe was in her, even by Maine standards. To the neglect of the hull, I think he had been totally beguiled by the rigging, its full complement of what the late Noank maritime historian Paul Steubing called "the passionate gear": ratlines, lazy jacks, dead-eyes and lanyards and baggy wrinkle. When the boat was delivered to Mystic from Maine via a hair-raising passage of hand pumping by its one-man crew, my father and I spent the summer trying to keep the "tired old girl" afloat, and when he hauled her in the fall, he discovered the extensive decay in the hull. After considerable epistolary back and forth to the broker, to no avail, my father decided to assemble a

kind of all-star visiting committee to drive with him the ten hours to 1950s Maine and confront the broker face-to-face.

Although the boat had nothing at all to do with Warner, my father persuaded him to join the posse for his quasi-ecclesiastical dignity as much as his architectural probity. But what would be the motive that would persuade Winthrop L. Warner to venture so far north in midwinter? At that period just before the fiberglass revolution, it was yet considered de rigueur for yacht architects south of Boston to keep their hand in with the mystique of the Down East wooden boat culture, no matter how fleeting the contact might be. As with his mentor John Alden, a good deal of Wink Warner's reputation at this time was because he was one of the designers who "kept his hand in." Owing to a recent marriage that held him close to home, he was aware that he had begun to appear negligent in paying his Down East dues. An all-expense-paid foray into this rewarding land with a two-time client would seem to fill the bill all around.

In addition to Warner, my father had along the family lawyer, a large man who spoke in a strange, midwestern whisper, and his youngest brother, a large man with a thrilling basso profundo voice. The brother had come up in the family construction business as a laborer foreman where his signature moment so far had been a confrontation involving a pickaxe during a steelworkers' strike at a paper mill job in Westfield, Massachusetts. The shop steward had called a strike with the key I beam in the air on the crane, an act to which my uncle took special umbrage. The pickaxe somehow played the part of what milder confrontations might call a "visual aid." It was a wonder no blood was shed. The trip to Maine was in the dead of winter, and the four men's bulk was further enhanced by their large coats and full-brimmed fedoras.

At the end of ten hours on Route 1, they were yet an hour away from their destination. Since it was dark and, despite their huge coats and a hard-thumping car heater, piercingly cold, they pulled into what would later be known as a bed-and-breakfast to prepare for the next day. After an unexpectedly good meal, the burly quartet was finally somewhat at ease in the parlor when Warner excused himself to make a phone call. Now in those days, such a simple transaction could only be accomplished from the gawky lone machine in the front hall. It was then that his companions realized that despite his middle age, their otherwise sophisticated companion had just been married and was, in the parlance of the time, "checking in" on his first night away from "the little woman."

What emerged from the hall was the residue of this marital exchange, and among the products was the news that Warner's bride was exceedingly

anxious that her groom would not on the morrow come to some sort of bloody end in the northern wilds.

According to my father, the Maine end of the conversation went something like: "Yes, we are in the heart of the traditional boat culture I told you about. Yes, dear. Of course, I am going to be very careful.…Yes, dear, I have considered what I will be saying and, yes, of course, as you say, *not* saying.…No, dear, no one has been drinking.…Well, of course the person who served dinner is, of course, one. Yes, actually rather matronly. No, dear, I do not believe that anyone is bearing arms.…Yes, dear, they do have proper authorities in Maine. We passed, as a matter of fact, a man on the way who had every appearance of being some sort of official of the law. Yes, dear, they do have medical facilities. And yes, in English…"

The next day, oddly enough it seemed to them, there was sunlight pretty much all over the landscape, which was bare and gnarly. It was like a cruel parody of Connecticut, what with big rocks and houses spaced well apart, several of the houses as unpainted as the rocks and some willing, it seemed, to fall down. In the car, they bumped down an increasingly narrow road, and the blue up ahead could only be the sea, but it did not seem the kind of sea you could use. Wink Warner came alive to remark that given the proportions of sea to land, you could see why all the windows were so small.

They stopped the car at a building that had the weathered sign that said it was the post office, but in no other way did it look like any other post office anyone had ever seen. The man inside had elastics on his sleeves but, instead of a green eyeshade, sported a long-billed swordfisherman's cap, much admired by my uncle, who was beginning to feel uncomfortable in his fedora.

The postmaster spoke in one of those accents that was hard to believe a person could keep up for more than five minutes, let alone want to sustain all day and, Lord knows, in this case, probably until the time he's in the ground. They didn't feel it especially wise to confide in him their actual purpose, but they did, after much evasiveness on both parties' part, elicit the address of the man they were seeking. During this evasive period, the postmaster excused himself and went in the back room, where they could hear him dialing and then whispering. When the postmaster returned, he seemed a bit more confident, as if he'd now done all he could.

Wink Warner was especially warm and, in the interests of professionally justifying his sojourn to Down East wooden boat culture, complimented the man on the boats that the region was known for, which only made the man nervous again. To the posse, it seemed like a good idea to get moving.

As the peninsula got narrower and narrower and houses fewer, it occurred to the men that there really hadn't been much purpose in inquiring of the postmaster except to serve to warn their prey.

When they had bumped on down to the end of the postmaster's directions, they also came to the end of what the peninsula had to offer. There was a lone, slightly crooked two-story frame house surrounded by boulders, set out, it seemed, like an armed guard but one that had never known discipline. Where the boulders ended, the sea began. There were no boats in sight.

Just as they pulled into what seemed a rock-free place near the side of the house, the back door flung open, and, coattails flying, a figure rushed down the steps and head-bent proceeded into the sloping field of boulders, a field that seemed locked in a frozen carom on down to the sea.

In a moment, he had vanished. The whack of the back door still seemed to be reverberating like a shot.

"There's nowhere he can go."

"The postmaster tipped him off."

"These old Yankees stick together. You got to admire that."

"He's crouching down there behind a boulder."

Wink Warner allowed that these rocks were called "glacial erratics" and made mention that they were, furthermore, perfectly characteristic of the region.

The four men in their greatcoats and fedoras sat in the rapidly cooling automobile, which rocked on its springs in the gusts, for there were no trees to break the wind. Despite the repeated slapping of the storm door, a seagull bombed the shed roof on the back of the house with something that it apparently had not yet found dead enough. No boats appeared. Without the engine running, the men began to congeal, like something left out on the counter too long.

"At least he has his coat."

"But he had no hat."

"It would have just blown off."

My father started the car to restoke the heater. "Sorry about this. All the way for…"

"It's okay," said his brother. "A day in Maine is worth a whole month…"

"I'm afraid it would have just been interpreted as caveat emptor," said the lawyer in his low, midwestern twang.

Wink Warner reiterated his sympathy for small windows in a maritime climate.

"Let's get the show on the road." My father gunned the engine. "Just wasting gas."

Since it was a long ride back home down Route 1 to Connecticut, and recalling the long ride of only yesterday to get there, everyone in the car agreed that they really had to get cracking. From the back seat, the lawyer explained with loving tenderness the ancient principle of caveat emptor. My father again apologized for the wild goose chase. Somewhere yet north of Boston, Wink said that this sort of thing was the very type of aspect of the naval architecture business that his new bride was just now coming to grips with.

When, a few years later, Warner won the contract to do a ferryboat for the river he grew up on, both he and his wife must have found the assignment a welcome relief.

TIMELINE

10,000 BCE–1614 CE: Dugout canoes, birchbark canoes, driftwood rafts

1641: Bissell's ferry established at Windsor

1650: Informal service between Ragged Rock Creek, Saybrook and Lieutenant River at Lyme established

1655: Rocky Hill–Glastonbury ferry established

1662: Saybrook-Lyme ferry established at Tilley's Point

1681: Hartford–East Hartford service established

1694: Chapman's Ferry, Haddam–East Haddam, established

1724: Brockway's Ferry, Essex-Lyme, established

1726: Izrahail Wetmore (wonderful name) begins Middletown-Portland service

1735: Roger Wolcott establishes a "double ferry" at Plymouth Meadow, Windsor

1736: Knowle's Landing, Middletown–Middle Haddam, established

1759: Higganum Ferry, Haddam–Middle Haddam, established

1763: Warner's Ferry, Chester-Hadlyme, established

1776: George Washington pays $1.35 to ferry his retinue from Old Lyme to Old Saybrook

1781: Five thousand French troops under General Rochambeau ferried from East Hartford to Hartford in three days

1783: General Assembly grants ferry charter to James Chamberlain at Windsor Locks

1808: Suffield-Enfield Bridge built

1808: Hartford–East Hartford Bridge built

1814: Haddam Ferry, Haddam–East Haddam, established

1832: Saybrook ferry landing renovated

1841: *Cora* built by J.A. Griswold

1843: Supreme Court battle between Hartford and East Hartford over ferry rights

1852: *Mattabasset* built by Middletown Ferry Company; ran until 1878

1859: *Spare Boat* of Middletown built in Portland

1864: Old ferryboat *Shoreline* sent from New London to serve Old Saybrook–Old Lyme

1870: *Portland* (largest ferry on the river at sixty-five feet) built by Middletown Ferry Company

1870: Ferry *Armsmear* built for the Colts

1883: *Cora* sold at auction

1883: *J.H. Goodspeed* commissioned

1884: *Emily A. Wright* built in Rocky Hill by Jos. Lord

1887: The *Gildersleeve* built in Cromwell; ran Rocky Hill–Glastonbury until 1894

1889: *Lady Fenwick*, steam ferry, begins service between Saybrook and Old Lyme

1889: Ferryboat *Portland* burns midriver

1889: Hadlyme Ferry Company placed in receivership

1889: *Brownstone* built; sold to Portsmouth, New Hampshire, in 1897

1895: *F.C. Fowler* built

1896: Middletown-Portland service ends

1898, November 22: *Lady Fenwick* sinks at her slip in Old Saybrook during blizzard

1899: *Middlesex* built

1902: Paddle steamer *Rocky Hill* built in Glastonbury, owned and operated by Town of Rocky Hill; abandoned in 1913, deemed unfit for service

1904: *General Spencer* built, privately owned until 1916

1905: The *Colonial*, built by Palmer in Noank, begins Lyme-Saybrook service

1906: Special ferry put into service to accommodate the Haddam Neck Fair

1911: Old Lyme–Old Saybrook automobile bridge built

1911: *Colonial* struck by lightning, burns at her slip

1913: Chapman's Ferry ends service in East Haddam

1914: The *Cheslyme* goes to New London for paddle wheel repairs, later sold at auction

1914, August 25: *General Spencer* sold to Captain Banning at auction for $80; she cost $6,000 to build

1915: *Middlesex* sold at auction

1924: *Selden I* built; cost $10,000

1924: *Emily A. Wright* decommissioned

1925: Connecticut state ferries lose $14,625

1938: *Selden II* built at Mystic

1950: *Selden III* commissioned

1955: "The Summer of No Ferry" in Rocky Hill

1955: *Cumberland* commissioned

1972: Budget woes threaten ferries

1989: Season passes are eliminated

1993: Billy Joel films *River of Dreams* at Rocky Hill ferry

2011: Towns rally to save ferries

SELECTED SOURCES

Barthelmes, Ed. "Ferryboats Avoid Obsolescence." *Morning Record*, April 10, 1976.

Biel, Alix. "Ferry Captain Finds an Anchor of Note in the Plying of His Craft." *Hartford Courant*, April 19, 1991.

Braden, Al. *The Connecticut River*. Middletown, CT: Wesleyan Press, 2009.

Byrnes, Robert. "Fight on Abandoning River Ferries Shaped Law at Bottom of Road Case." *Hartford Courant*, February 3, 1938.

Callaghan, Kelly. "Could a Reduction of Hours Ground Ferry?" *Rocky Hill Life*, April 1999.

Christopher, Gary. "Ferry to Run Again Soon." *Valley Courier*, July 3, 2002.

Connecticut Magazine. "History of a Religious Tract." August 1809.

Cox, Erin. "State's Only Female Captain Plies the Connecticut River." *Pictorial Gazette*, July 24, 1990.

Cudahy, Bryan. *Over and Back: The History of Ferryboats in New York Harbor*. New York: Fordham University Press, 1990.

Dagle, Shawn. "Banner on Ferry Prompts Outcry." *Glastonbury Citizen*, August 7, 2014.

Darcy, Tom. Personal interview, May 23, 2017.

Dean, Peter. "Ferry Thee Well." *Herald*, June 6, 1998.

———. "Working Relic, Oldest Route." *Journal Inquirer*, June 16, 1998.

Dunagin. "Budget Woes Threaten Little Bits of Nostalgia." *Hartford Courant*, January 14, 1972.

Dunn, W.M.P. *Thomas McManus and the American Fishing Schooners*. Mystic, CT: Mystic Seaport Museum, 1984.

Felson, Len. "Connecticut River Flooding Keeps Ferries from Beginning Runs." *Hartford Courant*, April 15, 1987.

Garney, Sandra. "Crew Members of Ferry Are Heroes." *Rocky Hill Post*, August 18, 1995.

Grant, Jim. Personal interview, April 17, 2017.

Griswold, Wesley. "Sound Your Horn to Call the Ferry!" *Hartford Courant*, May 12, 1940.

Griswold, Wick. *A History of the Connecticut River*. Charleston, SC: The History Press, 2012.

Gural, Andrea. "Ferry Marks 50th Year in Operation." *New London Day*, June 11, 2000.

Hard, Walter. *The Connecticut* (Rivers of America Series). New York: Rinehart, 1947.

Hartford Courant. "Captain Hills, Veteran Riverman Is Dead." March 1, 1929.

———. "Collins Employee Dies in South." November 18, 1916.

———. "Curious Old Ferry on Connecticut River at Bissell's Landing, Instituted by Pioneer Settlers Slowly Passing." October 2, 1921.

———. "Early Roads and Ferries, Streets Improved by Lottery." October 6, 1908.

———. "Engine Problem Puts Ferry Out of Service." September 7, 1993.

———. "Ferries Conducted at a Loss in Year." September 3, 1925.

———. "New Ferryboat for Rocky Hill." January 30, 1913.

———. "Oldest Ferry Plies the Connecticut." November 1, 1964.

———. "Passing of the Old-Time Ferry." June 3, 1913.

———. "Realtor Suggests Passenger Ferry over Connecticut." February 12, 1930.

———. "Those River Ferries Still Chug Along." August 27, 1972.

———. "Waiting for the Old Lyme Ferry." September 9, 1908.

Hawkes, Ben. Personal interview, May 5, 2017.

Hesselberg, Eric. "Ferry Celebrates Quiet Anniversary." *Herald Press*, June 13, 1999.

Hozier, Kathleen. "Weekend Time Change for Chester-Hadlyme Ferry." *Pictorial Gazette*, April 29, 1997.

Hubbard, Ian. *Crossings*. Lyme, CT: Greenwich Publishing Group, 1993.

Iwanicki, Howard. "Chester-Hadlyme Ferry Still Riding the Waves." *Record Journal*, May 30, 1985.

Keveney, Bill. "Tossing a Little History into Daily Commute." *Hartford Courant*, June 22, 1992.

Knauth, Steve. "Historic Ferry Losing Money, but Not Sense of History, Purpose." *Soundings*, October 1997.

Knight, Lucia del Sol, and Daniel Bruce MacNaughton. Foreword by Llewellyn Howland III. *The Encyclopedia of Yacht Designers*. New York: Norton, 2006.

Knox, Virginia. "Glastonbury Ferries." Glastonbury Historical Society, May 1956.

Kranhhold, Kathryn. "Hadlyme Ferry Area Stays Much the Same." *Shore Line Times*, October 2, 1989.

Kutcher, Eric. "Ferry Pilots Share History at Sea." *Glastonbury Citizen*, November 2, 1950.

LaBonte, Cathey. Personal interview, July 21, 2017.

MacWhirter, George. "Crossing the Connecticut...Once an Adventure for Hardy Souls." *Shoreliner*, 1950.

Maine, Doug. "Later, Rather Than Sooner on the Waterfront." *Rocky Hill Life*, June 2003.

Marshall, John. Personal interview, April 9, 2017.

McCain, Diana. "Bridging River Once Done by Ferry Boats." *Hartford Courant*, May 2, 1990.

Miller, Casey, and Kate Swift. "When the Shadbush Is Blooming." *Hartford Courant Magazine*, April 4, 1972.

Morrison, Maureen. "A Quiet Ride across the Connecticut." *Day Tripper*, October 21, 1999.

Motorship. "Selden III, New Steel Ferry." August 1950.

Motycka, Susan. "The Nyaug Ferry." *Glastonbury Citizen*, August 29, 1913.

Neal, Traci. "Boat May Soon Ferry Itself into Sunset." *Journal Inquirer*, September 4, 1996.

New Haven Register. "It's Relaxing to Take the Ferry." August 2, 1959.

New London Day. "Ferry Trip Tempestuous." September 22, 1881.

Olde Lyme Gazette. "The Old Ferry Linking Lyme and Saybrook." July 18, 1974.

Peck, David. "Started Before Revolution." *Middletown Press*, August 1, 1975.

Perry, John. *American Ferryboats*. New York: Wifred Funk, 1957.

Private and Special Laws of the State of Connecticut. New Haven, CT: Charles Chatfield and Co., 1871.

Reitz, Stephanie. "Ferry Crosses Slowly, Steadily into 343rd Year." *Hartford Courant*, May 2, 1998.

Republican American. "Ferry Supporters Lobby for Repairs." November 3, 2003.

Rossignol, Joyce. "People from All Over the World Cross the River on the Nation's Oldest Ferry." *Glastonbury Life*, July 2000.

Saluk, Kathleen. "Rapport with Horses Needed to Be Postmaster General." *Hartford Courant*, March 11, 1975.

Shepard, Odell. *Connecticut Past and Present.* New York: Knopf, 1939.

Smiley, Allison. "Ferry to Cross the Connecticut River Once Again." *Rocky Hill Post*, April 6, 1990.

Smith, Donald. "A True Son of the Long River Calls It a Day." *Hartford Courant*, July 12, 1942.

Squires, Betty. "When the French Army Came to East Hartford." East Hartford Historical Society.

Stannard, Charles. "Ferry Fare to Rise to 25 Cents." *Middletown Press*, March 23, 1993.

Stokes, Larry. Personal interview, April 6, 2017.

Thompson, Nancy. "Fans of Ferry Hope for Wave of Tourists." *Hartford Courant*, April 28, 1993.

Underwood, Melissa. "Chester Ferry Back at Work on River." *New Haven Register*, April 19, 1990.

U.S. Coast and Geodetic Survey. *United States Coast Pilot, Atlantic Coast: Section B Cape Cod to Sandy Hook.* Washington, D.C., 1933.

Van Ness, Claudia. "Ferryboat Features the Maestros' Touch." *Shore Line Times*, May 20, 1986.

Velsey, Kim. "Towns Try to Save Ferries." *Hartford Courant*, July 18, 2011.

Warner, Elizabeth. "The Tragic 1889 Fire That Claimed the Portland Ferry." *Patch Poster*, April 16, 2011.

Warren, William. "Season Pass a Thing of Past on Ferries." *Hartford Courant*, April 28, 1989.

Whittlesey, C.W. *Crossing and Recrossing the Connecticut River.* New York: Putnam, 1939.

Williams, Jack. *Easy On, Easy Off: The Urban Pathology of America's Small Towns.* Charlottesville: University of Virginia Press, 2016.

Williams, Mary. "Connecticut Ferry Service Keeps Moving." *Slow Lane Journal*, August 1991.

Wilscam, Rod. "The Rocky Hill–Glastonbury Ferry: 348 Years of Continuous Service." *Rocky Hill Life*, January 1999.

Woodside, Christine. "A Scenic Crossing and No Traffic Jams." *New York Times*, June 3, 2001.

————. "Unsteady as She Goes." *New London Day*, August 2, 1997.

Wright, George. *Crossing the Connecticut*. Hartford, CT: Smith Linsley, 1908.

Wright, Robb. "Bridge Repairs Popularize Ferry." *Hartford Courant*, June 5, 1986.

Wright, Sarah Bird. *Ferries of America: A Guide to Adventurous Travel*. Atlanta: Peachtree Publishers, 1987.

INDEX

ABOUT THE AUTHORS

Stephen Jones is professor emeritus in the Maritime Studies Program, which he co-founded for the University of Connecticut at Avery Point. He served his military obligation in the Coast Guard aboard an offshore lighthouse during the Mid-Atlantic Storm of the Century and later at a lifeboat station. His books on coastal culture include *Drifting*, *Harbor of Refuge*, *Back Waters*, *Short Voyages*, *Working Thin Waters* and the Flat Hammock Press editions of Ellery Thompson's *Draggerman's Haul* and the Arthur Henry/Theodore Dreiser *An Island Cabin*. He has been executive producer of numerous maritime documentaries, including *The Real McCoy*, winner of five Emmys, and *Ferryboats of the Connecticut River.* He and his son Captain Geoffrey Jones run two maritime facilities on the Mystic River. He has served on the Town of Groton Shellfish Commission since 1968. His first excursion on a Connecticut River ferry was with his parents just prior to the outbreak of World War II.

Wick Griswold is associate professor of sociology at the University of Hartford. His signature course is the Sociology of the Connecticut River. His books include *A History of the Connecticut River*, *Griswold Point: History from the Mouth of the Connecticut River* and *Pirates and Privateers of Connecticut*, all published by The History Press. He is associate producer of the documentary *Ferryboats of the Connecticut River.* He also hosts *Connecticut River Drift* on i-CRV Radio in Ivoryton, Connecticut. He is currently developing an educational project with the Connecticut River

Stephen Jones (*left*) and Wick Griswold at the Essex Boat Works observing the "splash" of the towboat *Cumberland. Photo by Jennah E. Smith.*

Museum and the Connecticut River Academy focusing on four hundred years of immigration into the Connecticut River Valley. He is commodore of the Connecticut River Drifting Society and lives where the river debouches into Long Island Sound.